watercolour techniques

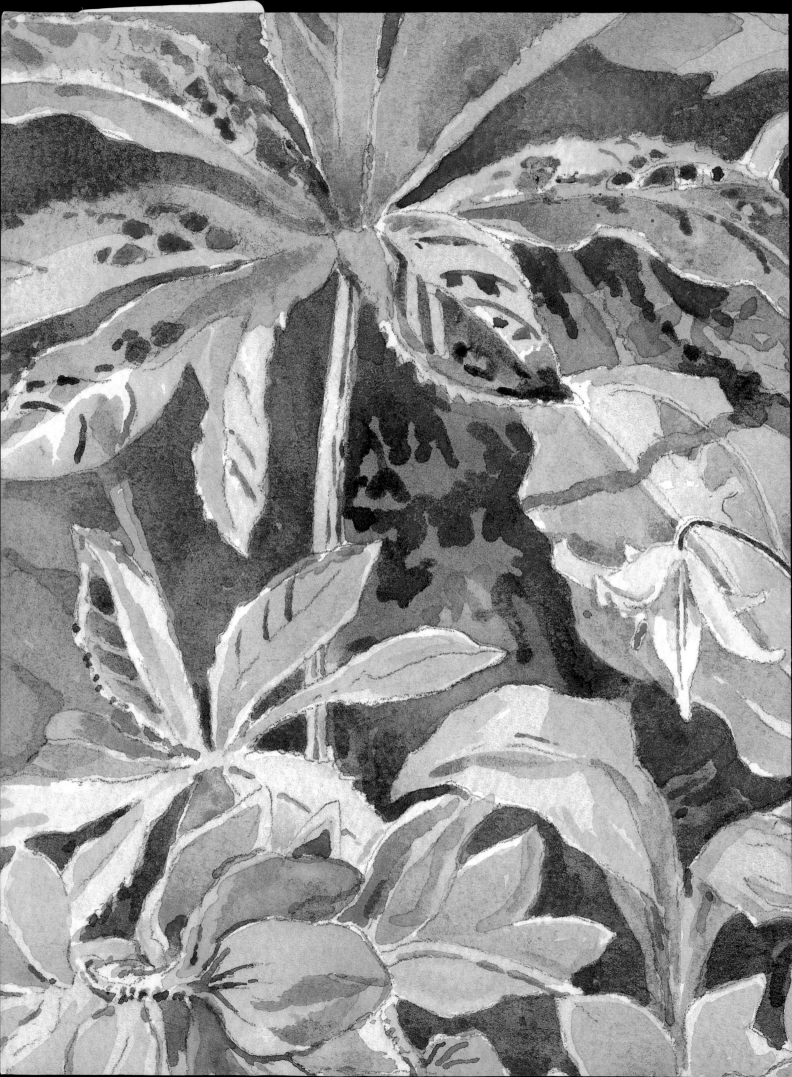

watercolour techniques

discover the secrets of great watercolour painting

JANE LEYCESTER PAIGE

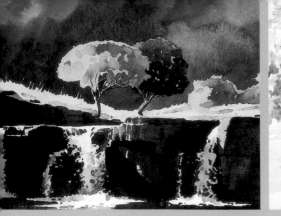

A QUARTO BOOK

Copyright © 2005 Quarto Publishing plc

Published by Apple Press
Sheridan House
114 Western Road
Hove
East Sussex BN3 1DD
United Kingdom
www.apple-press.com

ISBN: 1–84543–081–6

QUAR.WCR

Conceived, designed and produced by
Quarto Publishing plc
The Old Brewery
6 Blundell Street
London
N7 9BH

PROJECT EDITOR: Liz Pasfield
ART EDITOR: Stephen Minns
ASSISTANT ART DIRECTOR: Penny Cobb
COPY EDITOR: Fiona Corbridge
DESIGNERS: Brian Flynn, Michelle Stamp
PHOTOGRAPHERS: Robert Meadows, Paul Forrester, Ian Howes
PICTURE RESEARCH: Claudia Tate

ART DIRECTOR: Moira Clinch
PUBLISHER: Paul Carslake

Manufactured by Modern Age Repro House Ltd, Hong Kong
Printed by SNP Leefung Printers Ltd, China

9 8 7 6 5 4 3 2 1

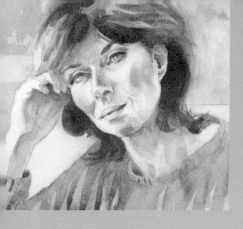

CONTENTS

INTRODUCTION

Painting is a challenge. It is frustrating, demanding and totally absorbing. To practise painting is to confront the world around us with heightened awareness. The potential for communication and great enjoyment lies in our fingertips.

I was brought up among watercolour. My father, his father and his grandfather before him were collectors of early English watercolour paintings. On summer holidays in Scotland when I was a child, our family often settled down on rocky riverbanks or hillsides swathed in scratchy heather to paint in watercolour.

Later, in my teens and early twenties, I rebelled against this rather Victorian form of art, dismissing it as old fashioned. I experimented with other media (and still do), but above all I loved to be outside. For me, there seemed no other way of painting that was so well suited to the immediate capture of light or the practicalities of expressing a great deal with the minimum of equipment. I began to study watercolour more seriously.

As I write, heavy rain clouds are building up to the south, pushing into a bright blue autumn sky against which the trees are darkly silhouetted. I make a note of it in my sketchbook. Paint is, after all, only a medium through which we express ourselves, and this book will help you to do just that – through the medium of watercolour.

RECORDING A MOMENT

Here is a quick sketch to record a moment of weather change. I used cobalt blue for the blue sky and to place the clouds; quickly added French ultramarine blue with burnt sienna to the wet, cloudy areas; and finally applied French ultramarine blue and aureolin yellow to the trees. With watercolour, the mood is expressed with immediacy, leaving no time for unnecessary detail.

HOW TO USE THIS BOOK

Part One, which shows you how to get started, sets the scene for you to understand the processes described in the demonstrations in Part Two. Please study the chapters in Part One carefully, then you will be able to enjoy getting inside the artists' minds as they create paintings in Part Two.

In Part Two, you will see how different artists exploit the medium to meet different moods and requirements. Each painting has been broken down into six stages, or layers. Of course, this is a simplistic way of showing thought processes, because what artist consistently plans a painting in six stages? But the idea is to help you understand the components of a painting and take encouragement from it.

THE LAYERS

Each layer is shown at the top of the page as a single separation with notes by the artist.

THE STEPS

Each page also has a series of close-up photographs showing the application of the paint and the working process involved.

MATERIALS

Each artist lists his or her materials at the beginning of the demonstration.

THE STAGES

The image at the bottom of each page shows the painting after the layer has been added. In this way, the building up of the picture can be followed along the lower part of consecutive pages.

THE COMPLETED PAINTING

The final image shows the finished painting. All the layers which make up the image have now been added.

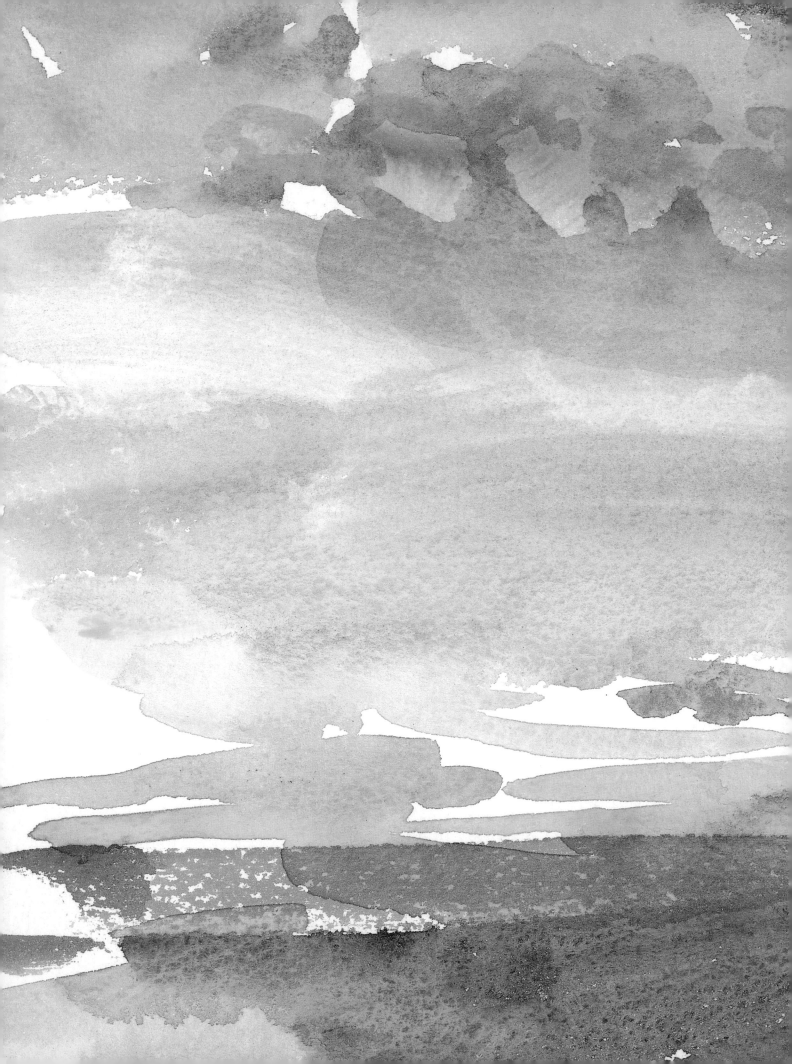

PART ONE

GETTING STARTED

In this section you will learn about some of the characteristics of watercolour and the equipment and materials needed to exploit them. The importance of keeping a sketchbook is stressed, and tone and basic colour theory are explained. You are also encouraged to experiment and play with watercolour to help you become familiar with its characteristics, and there are some suggested techniques to help you get started.

WATERCOLOUR CHARACTERISTICS

Watercolour has various characteristics that make it an interesting and rewarding medium to work with.

Any type of paint that uses water as a medium to dilute it may be called a watercolour – for example, gouache, acrylic, coloured ink, water-soluble coloured crayon and powder paint. Several of these may be incorporated into one painting. This book, however, will concentrate on the use of watercolour in its purest sense, because by understanding the particular qualities of watercolour, you can exploit it in any way you choose.

The main characteristic of watercolour painting is that the light in a picture is provided by the whiteness of the paper. When working in oil paint or pastel, light can be depicted by applying pale colours, which are often added towards the end of a painting. The shine on a glass, for example, is usually added almost as a finishing touch. When working in watercolour, the shine on a glass will come from untouched paper – an area that needs to be preserved throughout the painting process. This means planning ahead and developing the ability to think in negative. It is this use of the lightness of the paper that gives watercolour its look of ease and luminosity, belying the careful planning and control the artist must employ.

HIGHLIGHTS

To make the bright highlight on the glass, the white of the paper must be saved from the start.

TRANSPARENCY

Most watercolour paints have a degree of transparency, though some are much more transparent than others. With transparent colour, the whiteness of the paper is used as light shining through the paint. This light can be diminished with subsequent layers of paint.

Layers of transparent paint can also make new colours; for example, wash a transparent yellow over a blue to create a green, and a transparent blue over red to make a purple.

Permanent rose

Aureolin yellow

French ultramarine blue

TRANSPARENT COLOURS

Here is a selection of useful transparent colours. These colours allow the light from the paper to shine through.

Alizarin crimson

New gamboge

Prussian blue

Burnt sienna

Raw sienna

Viridian green

Brown over blue makes dark brown.

Yellow over makes green.

LAYERING TRANSPARENT COLOURS

Transparent colours can create visual mixes. Laying one transparent paint over another will produce the appearance of a third colour. Shown here are some of the mixes you are most likely to need.

Green over red makes grey.

Blue over pink makes purple.

OPACITY

Paints that are less transparent are described as opaque. They contain body colour (usually a chalky substance) to achieve the hue required, and this gives them a more milky consistency. Opaque paints are rich colours in themselves but do not mix as well as transparent paints do. Used strongly, they will cut out the light from the paper; a layer of opaque paint over another colour will hide the one underneath.

OPAQUE COLOURS

Here is a selection of useful opaque or semi-opaque colours. These colours are denser than transparent colours.

Naples yellow

Cadmium yellow

Yellow ochre

Cerulean blue

Emerald green

Cadmium red

OPACITY IN ACTION

Opaque colours are rich colours. When applied over another colour an opaque paint will mask the one underneath.

Opaque emerald green
over cadmium red

Cadmium yellow over
French ultramarine blue

Naples yellow over
burnt sienna

Cadmium red over
cerulean blue

Burnt sienna over
yellow ochre

Cerulean blue over
cadmium yellow

GRANULATION AND STAINING

Some watercolour paints are composed of pigment held in a suspension.
Often, when applied to paper, these paints have a tendency to granulate:
The grains of pigment separate and settle in the hollows of the paper.
This can be disconcerting but also effective. Other watercolour paints are
made of a dye that completely colours the water solution and will produce
an even stain on the paper.

Yellow ochre

Cerulean blue

Viridian green

GRANULATING COLOURS

This selection of granulating paints
shows how the pigments settle on
the watercolour paper. Don't be
alarmed by this uneven appearance;
it is normal and can be used to
great effect in your painting.

Permanent rose

Indigo

Quinacridone red

STAINING COLOURS

This selection of paints will stain the
watercolour paper evenly. These colours
are pure and difficult to change once on
the paper. They should be avoided if you
think you will be making alterations to
your painting as you progress.

French utramarine blue

Prussian blue

LIFTING OFF GRANULATING COLOURS

With many colours, it is possible to take out or 'lift
off' the paint from the painting surface with clean
water. This is easier to achieve with granulating
colours than it is with staining colours. Staining
paints will always leave a trace of colour. French
ultramarine blue is a granulating paint and is easy
to lift off when still damp. Prussian blue is a
staining paint and leaves a trace of colour behind
after it has been lifted off.

EQUIPMENT AND MATERIALS

There is a huge choice of material on the market to tempt you. To get started, it is wise to have a basic selection of good quality equipment rather than buying large quantities of cheaper products.

WATERCOLOUR PAINTS

Shopping list to get started:

Reds:
Alizarin crimson, scarlet lake and burnt sienna

Blues:
Cobalt blue, French ultramarine blue and cerulean blue

Yellows:
Aureolin yellow, lemon yellow and raw sienna or yellow ochre

There is no need to buy colours that can be mixed, but useful extra colours would be viridian green, dioxazine violet and burnt umber.

COLOURS

In the section on colour theory (see pages 26–31), you will learn how much variety can be achieved with just a few colours, known as a 'limited palette'. It is better to have a few colours of artist quality than a whole box full of student-quality paints. This is because artist-quality paint is made of purer pigment and does not dry out as quickly as student-quality paint. To begin with, you will need a small selection of primary colours in both warm and cool versions: some reds, some blues and some yellows. Three of each will give you a good start.

WATERCOLOUR PAINTS

Watercolour paints are sold in tubes and pans. The choice is a personal one, as both are of the same quality. Some artists prefer the tubes because they allow the artist to mix a larger quantity of paint without scrubbing at a pan, which can wear out the point of the brush. Others prefer the pans because they take up less room in the paintbox and leave the palette space free for mixing.

1

2

BRUSHES

There is an enormous assortment of brushes available, but one or two good-quality brushes will probably serve you better than a host of assorted shapes and sizes. What you choose will depend on how you like to paint: some artists use a 5 cm (2 in.) house-painting brush for broad washes; others prefer to use a fine sable brush. The choice between man-made fibre and natural hair is usually decided by cost! For large brushes, the man-made fibres work very well, and many of them taper to a beautiful point. For small brushes – size 4 downwards, for example – it is better to have one sable brush than a whole set of brushes made of man-made fibres. The difference lies in the structure of the material. Each natural hair has minute, backwards-pointing barbs, which means that its capacity to hold paint is greatly enhanced. Fine, smooth, man-made fibres do not have such a capacity; therefore, the paint in the brush needs constant replenishing, which can result in drier, more uneven application.

DIFFERENT BRUSHES

Selection of small round brushes (1), large round brush (2), rigger (3), small prolene sword (4), hake brush (5), small goat-hair mop brush (6), Chinese squirrel-hair wash (7), Chinese brushes (8 and 9), flat brush (10), fan brush (11), large squirrel-hair brush (12).

BRUSH CARE

Keep your watercolour brushes solely for watercolour painting. If you also paint in acrylic or any other medium, keep a separate set of brushes for that purpose.

LOOKING AFTER YOUR BRUSHES

Whatever the size or make of brushes you choose, they will serve you better if you take care of them. If you have to carry them around, the points need to be protected; an old ruler and a couple of rubber bands can be used to make a splint for them, and it is also possible to get specially designed tins or rolls for carrying brushes. In the studio, brushes are best stored in a jar with the points upwards, so that the air can dry them.

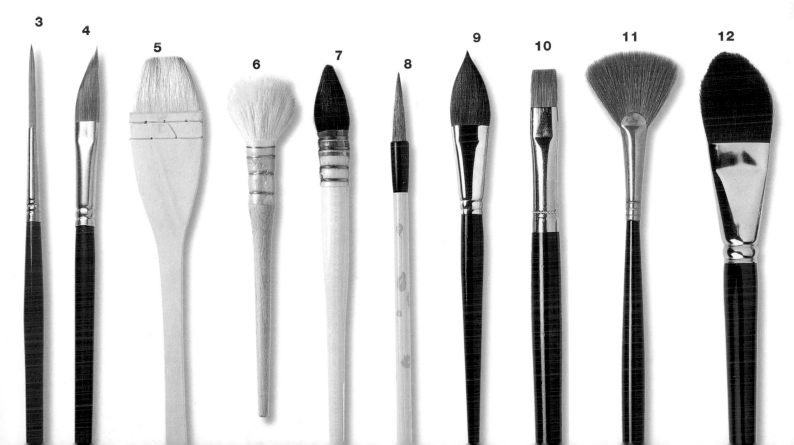

PAPER

You can paint on any paper with watercolour. Often, casual sketches made in a sketchbook have more charm than a fully thought-out painting executed on specially prepared paper.

However, to fully exploit the potential of watercolour, it is more satisfying to use a paper made for the job. There are many prestigious companies making paper for watercolour. Papers vary in character but are all described in terms of weight and surface. The weight is usually given in grams per square metre (gsm) and pounds (lb). A heavy paper, with a similar thickness to cardboard, weighs 630 gsm (300 lb). A light paper, similar to writing paper, weighs 190 gsm (90 lb). A commonly used weight of paper is 300 gsm (140 lb).

OTHER EQUIPMENT

Apart from paints, brushes and paper, you will need plenty of water for diluting the paint and washing your brushes, as well as a palette for mixing paints. A good support for your paper – firm but not too heavy (your own comfort is also important) – is also necessary.

PAPER CHOICE

The best watercolour paper is made from cotton rag. Look for the watermark; it appears on the side you should paint on.

DIFFERENT PAPERS

There is usually a choice of three different surfaces: hot press or HP, which is very smooth (1); cold press or NOT, which has a slight 'tooth' to it (2); and rough, which is noticeably rough surfaced or 'toothed' (3). By dragging a full brush of paint across three samples of paper, you will see and feel the differences in the surfaces.

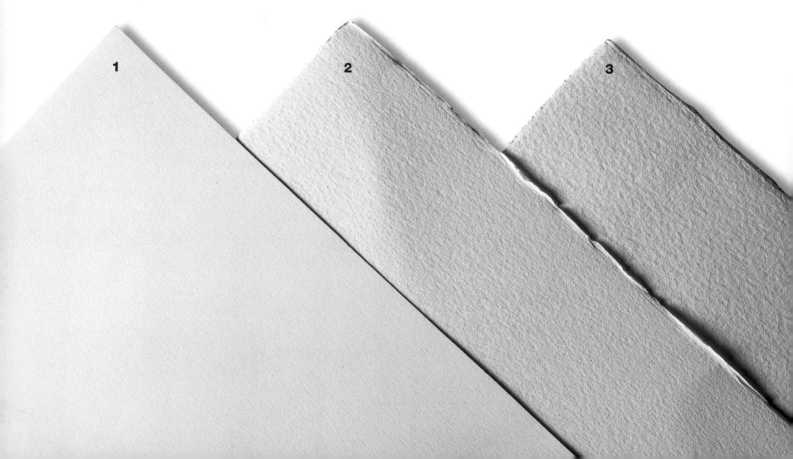

1 2 3

EASEL

An easel is not essential, but it is useful if you like to paint while standing. It must be adjustable so that the paper can lie almost flat. A table easel (pictured) can also be useful if space is not available.

DRAWING BOARD

A board is important for supporting your paper. It needs to be firm – the wood should not be less than 4-ply – and it should be unstained and unpolished. (If it is stained, the stain sometimes comes off on the back of the paper; if it is polished, the gummed paper will not stick when you are stretching your paper.)

MIXING PALETTE

For studio work, white plates or trays do very well as mixing palettes. For field work, a folding palette in either metal or plastic is useful.

PAPER TOWEL

Paper towels are preferable to rags, as they are cleaner and more absorbent.

SPONGE

A sponge is useful for 'lifting off' areas of paint (see page 40).

ALL ABOUT SKETCHING

Your sketchbooks are your source material. They are your record of observation, practice and ideas.

DIFFERENT SKETCHING TOOLS

It is often said that a would-be watercolour artist should learn to draw first. If the underlying structure of a painting is weak, clever painting techniques will not produce a satisfactory picture. Drawing and painting should be practised together, but the pencil is only one of many tools to draw with. Others include pen, charcoal, crayon and paint and paintbrush. The important thing is to learn to really look at your subject and to put down what you see on paper with whatever comes to hand. Try to become fluent with a variety of tools.

SOFT PENCILS

For quick and lively drawings, soft pencils in grades 2B to 9B are useful.

COLOURED PENCILS

Coloured pencils are useful to have on hand for making colour notes.

CHARCOAL

Charcoal is messy but lovely to draw with, helping you to be bold and strong in the marks you make. It comes in a variety of thicknesses.

PAINTBRUSH

Remember that your paintbrush is also a drawing tool. You can draw with the point and then quickly add bulk by filling in. A medium size with a good point makes a good sketching tool.

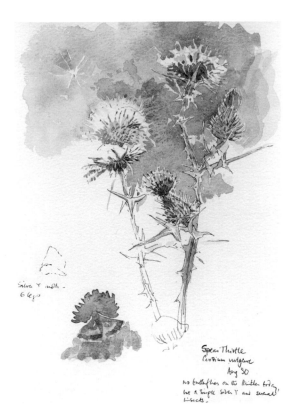

KEEPING A SKETCHBOOK

Like all skills, painting requires practice. Learning techniques is one thing, but you also need subject matter. With a sketchbook readily on hand, you are able to record observations and practise sketching.

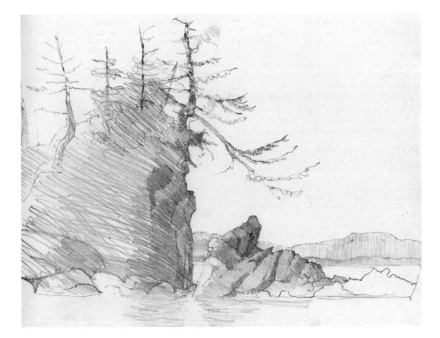

TEXTURES

Practise suggesting textures, using a variety of different tools, and making notes on your sketch.

SHADOW NOTES

Make a note of shadows and reflections when sketching. They are often more prominent than the subject casting them.

NOTING DISTANCES

Make a note of tonal relationships between distances. Look for relative size; for example, how far down the rock face does the distant hill begin?

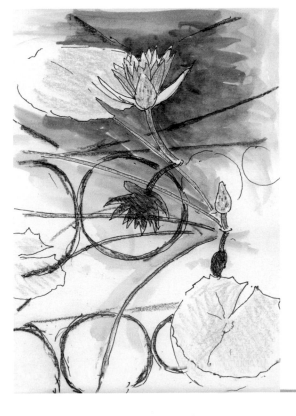

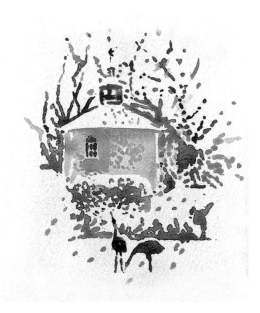

USING YOUR PAINTBRUSH

Sketching directly with a paintbrush helps you to look for the light and paint the dark. Here the snowflakes look dark against the sky and the snow-topped roof is light against the branches.

SUBJECTS FOR SKETCHING

Make scribbles, colour notes and daubs to record things such as a figure in action or the movement of water. You also need to make careful studies of buildings, people and natural forms, taking into account tone and perspective. Don't be afraid of making a mess or wasting paper, and have a sketchbook or paper on hand all the time.

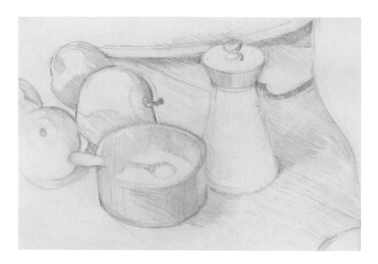

SKETCHING STILL LIFES

Here the salt cellar and the pepper mill, together with the apple, make interesting shapes framed by the bread board and the wine glass. They also provide very good practice for drawing ellipses.

SKETCHING FIGURES

Sketching figures at the airport is good practice for drawing people and helps pass the time during an otherwise tedious wait.

SKETCHING ANIMALS

Drawing with the paintbrush is ideal for quick action notes.

SKETCHING LANDSCAPES

Dramatic changes in the landscape due to variations in the light or weather can be recorded in your sketchbook for future inspiration.

SKETCHING AS THE BASIS OF A PAINTING

By using your sketchbook to plan out a composition, you can scribble, draw and erase as much as you like without worrying about spoiling the surface of the paper for painting. Make a note of bulk shapes and the direction of the light.

THE INITIAL SKETCH

Use the shapes in the sky as part of your composition. Here the clouds start a zigzag that continues into the land mass.

PLOTTING THE COMPOSITION

Having worked out the composition in your sketchbook, you can plot it onto watercolour paper with confidence.

FINAL PIECE

The painting is developed with more strength and a minimum of detail.

ANALYSING TONE

Tone is relative dark and light, giving form without line or colour.

Think of a black-and-white photograph. The image is depicted through a pattern of light and dark, and all the stages in between. You know what you are looking at purely and simply from the way the lights and darks relate to each other. Tones underlie everything seen, and artists become accustomed to looking for them in everyday objects, as well as in their chosen subject matter.

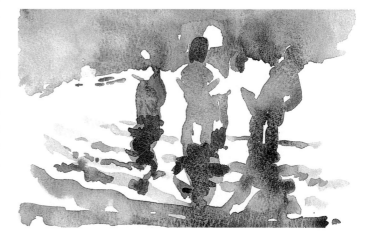

BLACK-AND-WHITE PHOTOGRAPH

These children, together with their reflections, make strong vertical shapes. Crossing the picture, there are the horizontal shapes of the bank and the ripples in the water. The absence of colour makes it easier to see this pattern.

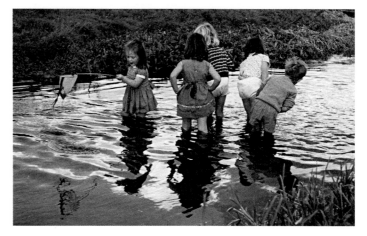

TONAL SKETCH

In a linear drawing, edges are defined by lines; a line pattern is produced on the paper. In a tonal drawing, edges are defined by areas of tone. The tonal pattern may cross over the line pattern; note how the children and their reflections make one continuous shape.

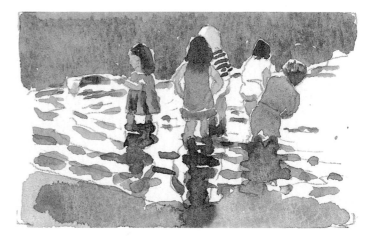

COLOUR SKETCH

Now look at a coloured version of the same scene and look at how the tones of the colours match up to the black-and-white tonal sketch.

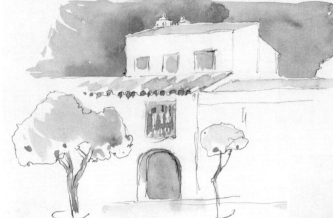

LOOKING FOR TONE

When you are sketching outside, look for the pattern of light and dark. Which direction is the light coming from? On a sunny day, this is easy to ascertain, for shadows will be pronounced. A building lit up by the sun may well appear paler than the sky. Emphasizing the deep tone of the sky will make the building bright in the sunlight.

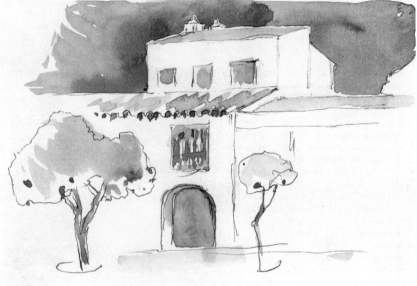

SUN SHADOWS

When you look at a building in bright sunlight against the sky, the building will appear much lighter than the sky.

It is important to paint the sky a deep enough blue to emphasize this contrast and achieve the warm, sunny light that is so reminiscent of the Mediterranean.

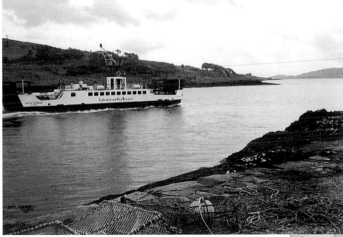

WATER TONES

This photograph shows a very different scene: a grey, damp day in Scotland. The tonal contrast is between the sea, which reflects the sky, and the land. The land is much darker than the sky and water, and even the foreground rocks have little tonal contrast.

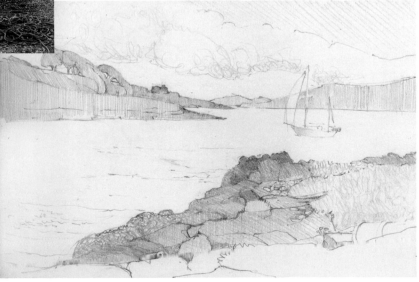

When it is too cold or wet to sit outside and paint, make a carefully observed sketch of the tonal relationships of shapes and forms. The foreground is dark when contrasted against the water, but the passing yacht is almost the same tone as the water.

MAKING A TONAL PANEL

Living beings use sight in practical ways; it is part of their 'survival kit'. Humans, for instance, may use their sight to judge the distance between them and an oncoming car. However, humans' aesthetic use of sight is less well developed. An artist needs to cultivate this use of sight to look for relationships between colour and tone, and shape and colour. It will then become second nature, giving rise to constant speculation and curiosity about things that are not crucial to survival but are of endless fascination.

To help you understand tone, make some tonal panels. First make a panel with black and white paint. Then make others with neutral mixes, in various intensities.

BLACK-AND-WHITE TONAL STRIP (BENCHMARK STRIP)

It is a useful exercise to make a graded tonal panel from white through black. This is a practical way to understand tone. Mark out a strip of ten squares on a sheet of paper, making the size of the squares about 2 cm (¾ in.). Now fill in the squares with paint, grading them from white to black. (Chinese white and ivory black are good paints to use.) Start with the white in the first square, and add a minimal amount of black to increase the darkness of each subsequent square until reaching pure black. This tonal panel will act as a benchmark strip for the tones in your painting. (Most of the time, it is not necessary to use black or white paint in watercolour.)

MAKING COLOUR STRIPS

Try matching colours against the benchmark strip. Start with a yellow. Look at how close to the white it is in tone compared to the blue, which is much darker in tone.

COLOUR STRIP

BENCHMARK STRIP

Chinese white

NEUTRAL STRIP

Water only

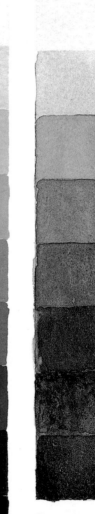

Ivory black

'Three primary colour' black

MAKING A NEUTRAL STRIP

Now make another strip of up to ten 2 cm (¾ in.) squares. Mix a neutral grey by using three primary colours (here: cobalt blue, scarlet lake and aureolin yellow). Use this mixture to make a panel that matches the benchmark strip in tonal value. Start with pure water in the first square to match the white paint, then use less water and more paint in the following squares. You will not achieve black, but you will be able to make a good dark tone. Now try the same procedure with other mixes of primary colours. For example, try using ultramarine blue instead of cobalt blue to reach a darker tone.

USING A TONAL PANEL

To practise recognizing tones in colours, make a graded tonal panel of five 3.75 cm (1½ in.) squares. Leave the first square blank to match your paper. Grade the tones in even steps towards a dark that is not quite black. Move this panel around your painting. Notice how the edge of the different squares in your strip will almost 'disappear' when matched with a part of your picture that is of the same tonal value.

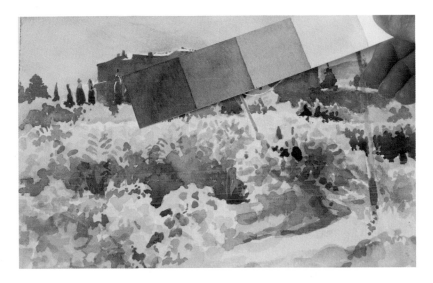

CONTRASTING TONAL VALUES

In this bright, sunny painting, the tonal contrasts are very marked. The building – which is backlit by the sun and silhouetted – is a dark tone. The surrounding sky is much lighter.

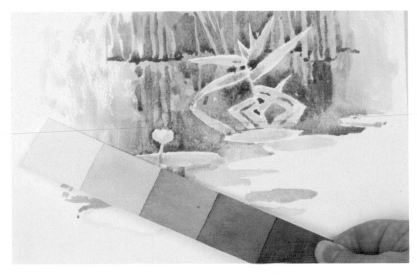

SOFT TONAL VALUES

By playing down the tonal values between the reeds and the water – and emphasizing the contrast between the water lily and the water – attention is focused on the flower.

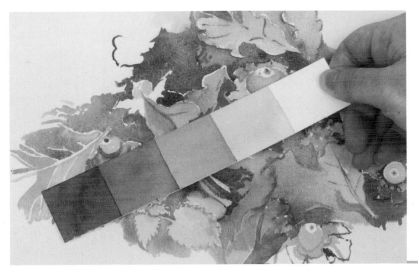

CLOSE TONAL VALUES

The leaves and fungi on the shady woodland floor are all very close in tone. There is just enough contrast to define the shapes.

UNDERSTANDING COLOUR

Colour is seductive and reflects our moods. With an understanding of simple colour theory, it is possible to manipulate paint in a most expressive way.

THE COLOUR WHEEL

Look at the colour wheel adapted from Itten's *Elements of Colour*. In the centre are three *primary colours* (red, yellow and blue) and three *secondary colours* (orange, green and purple). In the circle around are 12 colours of the spectrum, all derived from the primary colours in the centre.

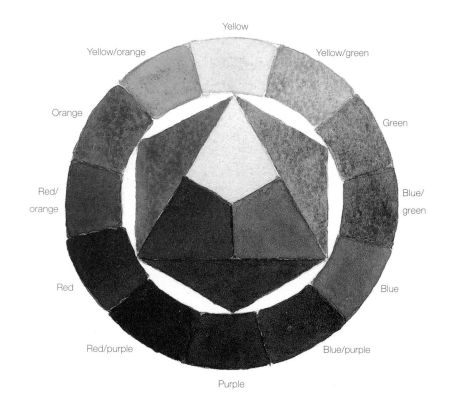

Yellow

Yellow/orange

Yellow/green

Orange

Green

Red/orange

Blue/green

Red

Blue

Red/purple

Blue/purple

Purple

COMPLEMENTARY COLOURS

Complementary colours are found on opposite sides of the colour wheel. 'Complementary' describes the relationship between a secondary colour and the primary colour left out of it. Thus orange is the complementary colour of blue, green of red and purple of yellow. Used alongside each other, complementary colours 'zing'. Here are three sets of examples that show complementary colours using three different sets of primary colours. Tonally, you will see that the red and green are very close together: the contrast is entirely in the colour. Blue and orange show more contrast, but the yellow and purple show the strongest contrast.

Green mixes

Orange mixes

Scarlet lake

Permanent rose

French ultramarine blue

Cobalt blue

PRIMARY COLOURS

In the world of art, the three primary colours are red, blue and yellow (however, in the world of science, the primary colours are red, green and blue). They are called 'primary' because none of them can be made by mixing any other colours. But by mixing combinations of red, blue and yellow, it is possible to achieve all the colours in the spectrum.

Yellow

Red Blue

SECONDARY COLOURS

When two primary colours are mixed together, it creates a secondary colour. The remaining gaps on the wheel will be filled by *tertiary colours*, which are each a mixture of one primary and one secondary colour.

Orange Green

Purple

WARM COLOURS

The colours around the red remind us of fire. They are described as 'warm' colours.

COOL COLOURS

The colours around the blue are reminiscent of water or night, and they are thought of as 'cool' colours.

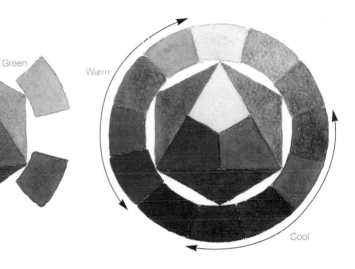

Warm

Cool

MIXING COMPLEMENTARY COLOURS TOGETHER

When complementary colours are placed next to each other, they enhance each other. But when mixed together, they produce a whole range of neutral browns and greys. The middle sections of each of these strips are very similar; in each case, there is an equal combination of all three primary colours making up the grey.

Purple mixes

Lemon yellow Aureolin yellow

Orange Blue

Red Green

Yellow Purple

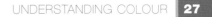

LIMITED PALETTE

In the colour wheel on page 26, the yellow used is aureolin yellow, the red is permanent rose and the blue is cobalt blue. These are all transparent colours that mix well. Although permanent rose is more of a bluish red than an orangish red, it has been used here because it mixes well to make both a good purple and a good orange, whereas scarlet lake makes a good orange but a dull purple. In choosing a limited palette for a painting, it is worth choosing primary colours that mix well in both directions of the spectrum, such as the ones listed below.

GETTING STARTED

REDS

There are many different red paints ranging between alizarin crimson (a bluish red) and scarlet lake (an orange red), and each one will have its own characteristics. Some are transparent, others are opaque, some stain, and others may be lifted off with water.

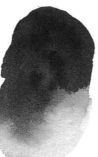
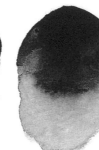

Cadmium red　　Scarlet lake　　Permanent rose　　Alizarin crimson

BLUES

Blues range from cool, greenish blues to warm, purplish blues. The blues pictured here are a good start for a beginner's palette.

Phthalo blue　　Cerulean blue　　Cobalt blue　　French ultramarine blue

YELLOWS

There are cool yellows and warm yellows. Lemon yellow is cool, pale yellow and cadmium yellow are warm with more orange influence. Cadmium yellow is opaque, whereas new gamboge is transparent.

Lemon yellow　　Aureolin yellow　　New gamboge　　Cadmium yellow

MAKING GREENS

All colours lean towards one or another of the primary colours. For example, burnt sienna is a warm colour, leaning towards red; and raw sienna is a lighter, cooler colour, leaning towards yellow. By using a warm colour in a mixture, an element of red is introduced, even though it may be almost undetectable. It is particularly important to understand this when making greens.

LIGHT GREENS

A bright green is best achieved by using cool yellows and blues. Here Prussian blue is mixed with lemon yellow.

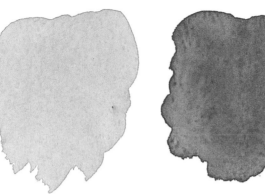

DARK GREENS

To make a darker, duller green, a warm yellow, or cool blue could be used. A touch of red added to a bright green will have the effect of making it a greyer green. Remember that it is always possible to dull down a colour by adding its complementary colour, but it is difficult to reverse the process. Here warm French ultramarine blue and warm cadmium yellow make a dull green.

Viridian green with alizarin crimson

Viridian green with aureolin yellow

Viridian green with raw sienna

Viridian green with burnt sienna

READY-MADE GREENS

It is not necessary to buy ready-made greens if you have decided on a limited palette, although most artists have a favourite that they use from time to time. Viridian green is one such green. It is a violent colour on its own, but it is very adaptable when mixed with other colours, particularly because of its transparent qualities. It is a bluish green, so it can be used throughout a painting in place of blue.

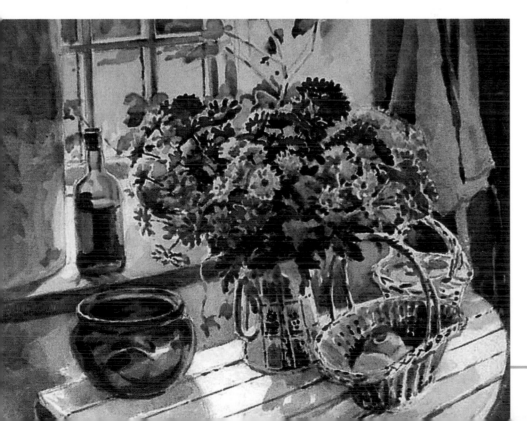

FLOWERS AT A WINDOW

In choosing the colours for this painting, viridian green was treated as a blue. Mixed with red, it made a neutral colour for the shadows; but mixed with yellow, it produced a bright green. Using the viridian green in both mixtures helps to harmonize the colours in what could have been a complicated painting.

EARTH COLOURS

Earth colours were originally derived from minerals in the soil and were among the earliest paints to be used. Examples of earth colours are burnt sienna, raw sienna, yellow ochre (a cooler and more opaque paint than raw sienna), burnt umber and raw umber.

Burnt umber

Burnt sienna

Raw umber

Raw sienna

Yellow ochre

EARTH COLOURS IN USE

Layers of raw sienna and burnt sienna have been used in this painting to express the quiet brightness of an autumn twilight. A final wash of burnt sienna over the foreground softens the grass detail and enhances the brightness in the sky.

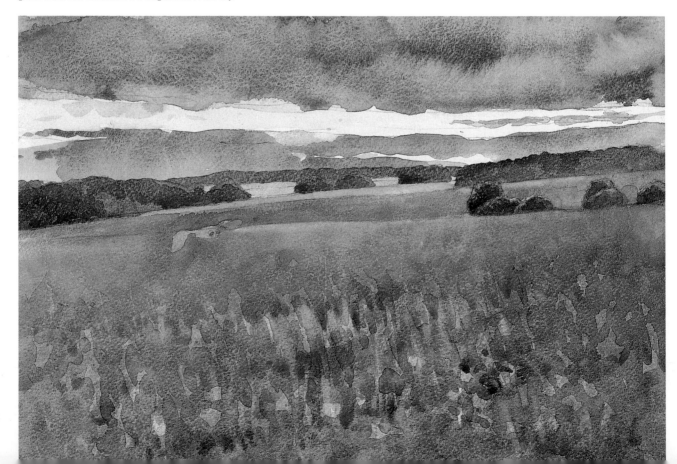

GREYS

Greys can be made by using a mixture of any three primary colours. Burnt sienna, which is an orange/red, already has red and yellow in its composition. By adding a blue (the third primary), some lovely greys can be achieved.

Burnt sienna with cerulean blue

Burnt sienna with French ultramarine blue

Burnt umber with French ultramarine blue

OTHER GREYS

The reason that burnt sienna mixed with blue makes a good grey is that it is an orange-red; that is, red and yellow are already hidden in its make-up and, together with the blue, all three primary colours are involved.

In the same way, viridian green mixed with alizarin crimson produces a good grey. Hidden in viridian green are the two primaries blue and yellow; by adding the third primary (red, in the form of a transparent alizarin crimson), grey results. Many other permutations of mixes will make greys, but they will always involve the three primary colours in some form.

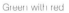

Green with red

Orange with blue

Yellow with purple

MIXED GREYS

A mixture of phthalo blue, permanent rose and aureolin yellow creates grey in this painting. The mix is varied in strength and warmth. The aureolin yellow and permanent rose are also used separately to create unobtrusive touches of colour in the sky.

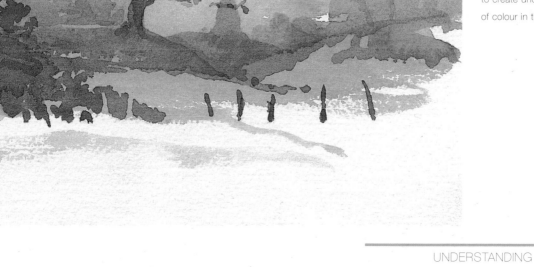

TECHNIQUES AND PRACTICE

Some knowledge of the basic techniques combined with practical experience will help you to gain confidence.

STRETCHING PAPER

When paper becomes very wet, it has a tendency to buckle, and an uneven flow of paint will result. Often this does not matter, and the very unevenness can add vitality to a painting. At other times, more control is required; if that is the case, it is advisable to stretch the paper first. This ensures a flat, taut surface on which to paint.

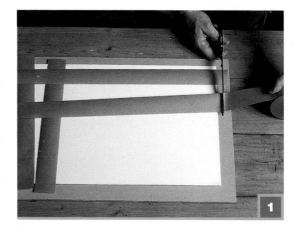

STEP 1 With dry hands, cut four strips of gummed paper tape, slightly longer than the sides of the painting paper. Then put the roll of gummed paper away in a dry place – it should always be handled with dry hands.

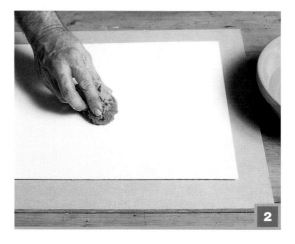

STEP 2 Thoroughly wet the paper to be stretched on both sides using a sponge. The paper can also be left in the sink for a few minutes or held under running cold water on both sides.

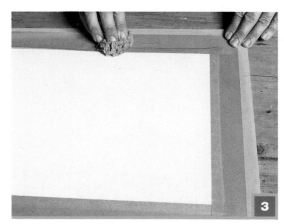

STEP 3 Lay the wet paper flat on the board and tape it down all around with the strips of gummed paper tape. This needs to be done neatly, giving straight sides to the paper and good corners. The tape should overlap the edge of the paper by at least 6 mm (¼ in.). To remove the work from the board, hold a craft knife vertically on the edge of the paper (where it can be seen through the gummed paper tape), and cut through the paper tape.

HANDLING PAINT

Watercolour is a sensuous medium, full of rhythm and flexibility. To get the best out of it, the brush needs to be held lightly and the arm movement should come from the shoulder rather than from the wrist. It is a partnership between the artist, the medium and the surface upon which the painting is being done. The artist is boss, but should be responsive to the whims of the watercolour and its interaction with the paper. Practise enjoying the paint for the paint's sake. Spend time playing with watercolour.

SQUEEZING PAINT

When using paint from a tube, squeeze it out on the edge of the palette. The bowl of the palette is then free for the paint to be mixed to the required intensity; the rest of the paint remains as a reserve.

STEP 1 Make a large wet area. Drop some undiluted colour into the middle of the wet area and watch what happens.

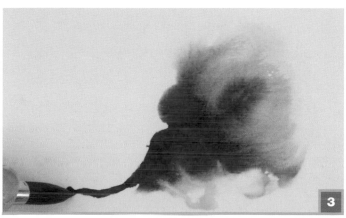

STEP 2 Add more colour, then add a larger blob of a different colour into the middle of the wet paint. Watch the paint again.

STEP 3 With the point of a brush, drag the paint out from the centre, through the wet area and onto the dry part of the paper. Notice what happens.

WASHES

A *wash* is an even layer of thin, transparent colour spread over a large area of paper. It is a technique worth acquiring, for although not often used in the rigid fashion described here, it is (in adaptation) invaluable in the build-up of a painting.

LAYING A FLAT WASH

To lay an even wash of watercolour requires control. To achieve the greatest control, it is best to work on stretched paper, although this is not essential. If the wash is to be applied to paper that has not been stretched, use two clips at the top of the board to hold the paper in place. As the paper becomes wet, it will expand; leaving it unsecured around the edges allows for this expansion.

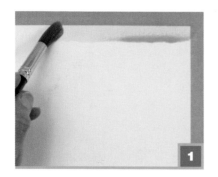

STEP 1 Dip a large brush in the water and take up a good load of the wash mixture. Starting at a top corner of the paper, drag the brush firmly across the paper to the other top corner. By keeping the board slightly tilted, there should be a channel of excess colour along the bottom edge of the brushstroke.

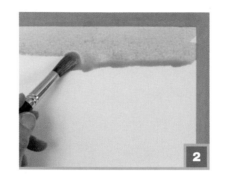

STEP 2 Reload the brush and sweep it across the paper again, gathering up the excess from the first brushstroke.

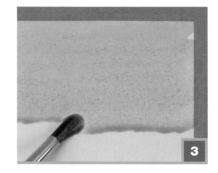

STEP 3 Continue in this way, gathering up the excess from the previous brushstroke each time, until the bottom of the paper is reached or the extent of the required wash is achieved.

STEP 4 To maintain an even flow, it is important to work firmly and quickly, keeping this rhythm: dip brush in water, load with mixture, sweep brush across paper.

STEP 5 When the bottom of the paper has been reached, wash and dry the brush and gather up the final excess in a single sweep.

STEP 6 If, by chance, the wash has failed to cover some patches of paper, do not try to fill them in or go back over the paint, as an unevenness and 'cauliflowering' will result.

LAYING A GRADED WASH

To make a graded wash, start with a strong mixture (as for a flat wash), but use more water and less mixture for each brushstroke, until almost pure water is used. Wash and dry the brush for the final brushstroke, gathering up the excess water.

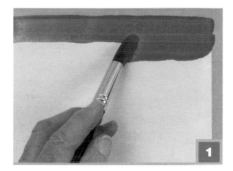

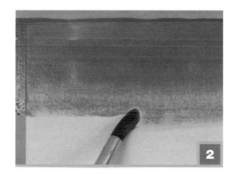

STEP 1 Begin with a loaded brush of colour and, starting in a top corner, sweep the brush across to the other corner of the paper.

STEP 2 Gradually use less paint and more water for each sweep of the brush.

STEP 3 Finish with a dry, clean brush.

LAYING A SECOND WASH

If a second, deeper-coloured wash is required, it is important to wait until the first one is quite dry; then apply the second with a less dilute mixture. This second wash may be of the same colour as the first, or of a different colour. Some papers are more receptive to layers of washes than others are, and it is up to you to practise and experiment.

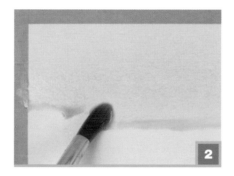

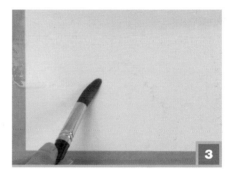

STEP 1 Wait until the first wash is dry before adding another graded wash in a different colour. Use a strong colour for the first sweep of the brush. It will become less dense as you continue.

STEP 2 Add more water and less paint.

STEP 3 Finish with a dry, clean brush.

WHEN TO APPLY A WASH

A wash can be applied at any stage during the progress of a painting, and over all or only part of the paper. Sometimes it is a good way to start a painting. It can serve the double purpose of dampening the paper and setting the atmosphere. By leaving some areas dry, the lightest parts of the painting can be established early on. These will be enhanced later on when further paint has been added to the wet area, which will also stop when it meets the dry part.

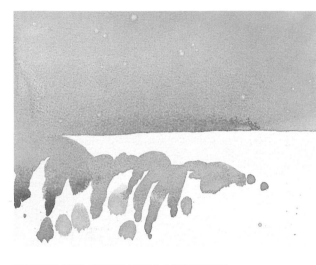

SETTING THE SCENE FOR A LANDSCAPE

A raw sienna wash has been taken over most of the paper, stopping where the far shore comes into the picture and then taken up again in a broken fashion in the foreground to suggest the bulk of reeds.

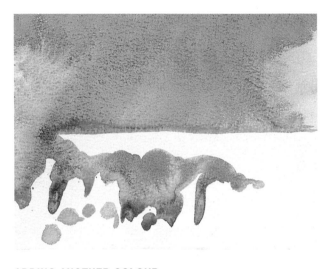

ADDING ANOTHER COLOUR

While the wash was still wet, Prussian blue was dropped into the sky and also into part of the foreground.

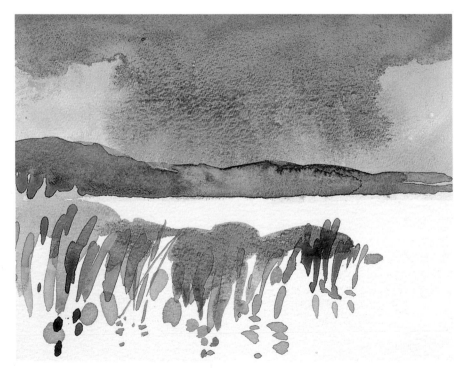

ADDING DEFINITION TO
THE LANDSCAPE

As the wash dried, the far hills and shoreline were brushed in and the reeds and their reflections were suggested with more Prussian blue. The mood has been set for the picture, and there is time now to pause and reflect on how best to proceed.

THE EFFECTS OF A WASH

A wash applied over some part of a painting, halfway through, can have the effect of softening harsh marks. It will also reduce the contrasts within an area of shadow. This helps to concentrate the attention on areas where the contrasts are greatest.

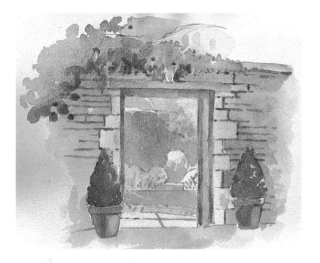

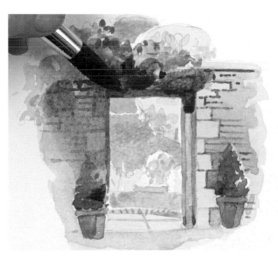

REASONS FOR A WASH

In this painting, the eye is drawn to the shrubs in the pots, where the contrast is strong. The brickwork is very harsh; it is also difficult for the viewer to see past the wall.

PUTTING ON THE WASH

A wash of a mixture of viridian green and alizarin crimson is painted all over the wall and the shrubs in the pots.

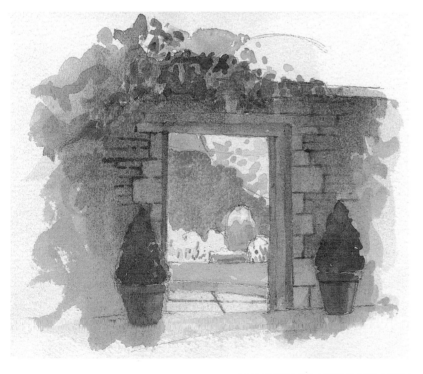

CHANGING THE FOCAL POINT

The effect of this wash has put the wall in shadow, at the same time softening the harshness of the brickwork and reducing the contrast around the shrubs in the pots. The viewer is invited through the gate into the sunlit garden beyond.

EDGE EFFECTS

It is important to learn how to control the edges in your paintings. If the paint is applied to dry or nearly dry paper, it will stay where it is put, and a hard edge will occur. If applied to damp or wet paper, it will spread, and a soft edge will be achieved.

DRYING TO HARD EDGES

 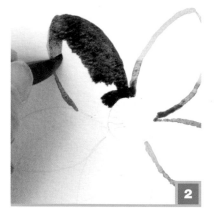 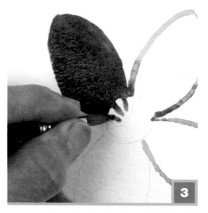

STEP 1 Paint onto dry paper. Create the edge of the petal with a firm sweep and plenty of paint.

STEP 2 Avoid unsightly hard edges by filling in quickly.

STEP 3 Draw around the shape of the stamen while the paint is still wet.

DRYING TO SOFT EDGES

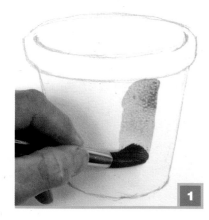 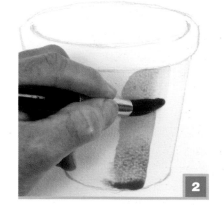 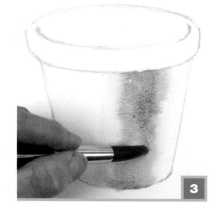

STEP 1 Dampen all of the area of the flower pot and use a rich strong mixture of colour to paint the darkest part of the pot.

STEP 2 Wash the brush and sweep it down the edges that are to be softened.

STEP 3 Add more strong paint in the centre and allow it to disperse towards the edge.

PLAYING WITH MULTIPLE COLOURS

Much can be learned just from playing with paints; experiment with mixes, use pure colours and allow them to mix on the paper, try painting on both dry and damp paper, taking notes of the different results. You may make a mess, but you will learn new techniques, and you could get some really beautiful results.

PAINTING WITH PURE COLOUR ONTO WET PAPER

Yellow paint is dropped into wet paper, followed by almost undiluted scarlet lake. Viridian green is added around the scarlet.

More viridian green is added; but as the yellow is drying, it doesn't travel far. All three colours collect in a brown puddle where the dampened paper meets the dry edge.

USING MIXTURES ON DRY PAPER

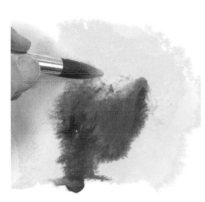

A rich mix of French ultramarine blue and burnt umber is painted onto dry paper. A mixture of scarlet lake and cadmium yellow is painted below this, leaving white space at first, and then merging into the blue mix.

Where the two mixtures touch, a soft blending occurs.

TONAL VALUES AND COMPLEMENTARY COLOURS

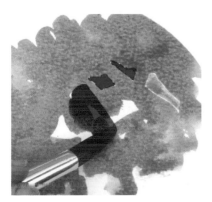

A large patch of pure viridian green is painted onto dry paper, leaving some random holes. When the viridian green is dry, the holes are filled with the tonally similar cerulean blue and the complementary colour, scarlet lake.

The cerulean blue is difficult to see as it is tonally close to the viridian green. The filled-in patches of red sparkle against their complementary green.

LIFTING OFF

Another technique worth practising is *lifting off*. Some paints can be readily removed with a wet brush, a sponge, or a piece of clean paper towel. This can be useful for creating highlights on fruit, for example, or for making clouds (where a soft edge is required) by removing paint from a sky.

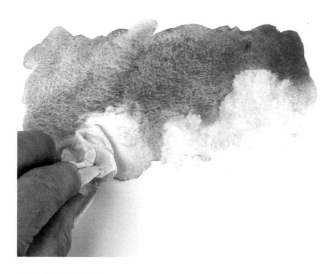

MAKING CLOUDS

Make sure that the paint is still damp. Lift out the shapes of clouds with clean paper towel.

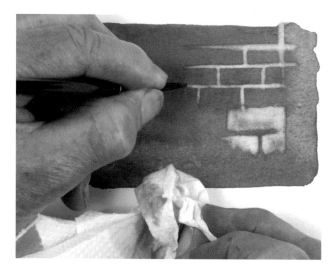

MAKING LINES

A clean, size 6 brush is used to lift out lines and suggest the shape of bricks in a wall.

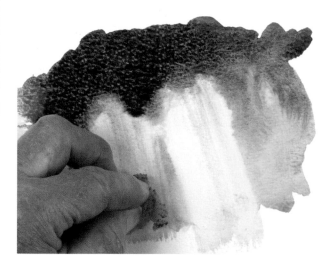

MAKING RAYS OF LIGHT

Use a natural sponge and wipe downwards with a strong movement.

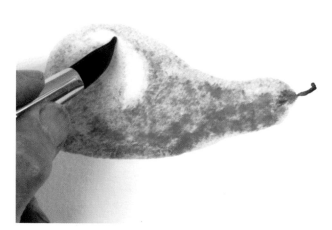

CREATING HIGHLIGHTS

Use a clean, wet brush to lift off the paint and create soft highlights. Wipe the brush after each movement. Repeat until the highlight is as strong as you wish it to be.

DRY-BRUSH TECHNIQUES

Dry brush is a technique that requires your brush to be almost dry or only slightly damp before it is loaded with paint. It is a useful technique for producing rough textures, such as stones, wood grain, grass and rough water. Dry brush used on rough paper can also suggest texture and light.

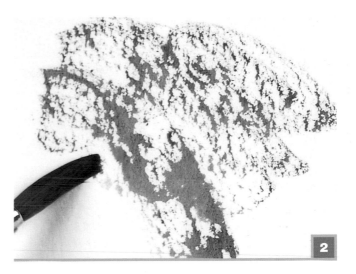

STEP 1 Wipe the brush dry and dip it into a rich mixture of paint. Then, using the side of the brush, stroke quickly and lightly across the surface of the paper, leaving flashes of light in the marks.

STEP 2 By experimenting, you will soon find the optimum pressure when dragging the brush to give a rough texture on the paper.

STEP 3 When less pressure is applied, more white paper shows through. A directional effect can also enhance the roughness of the paint for a beautiful grained effect.

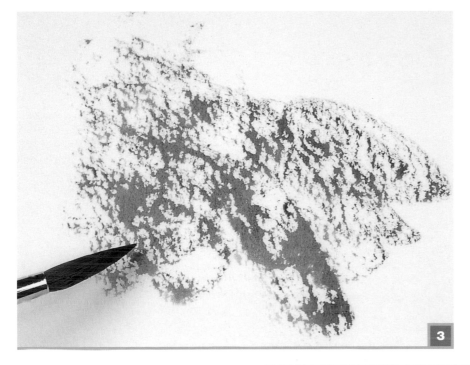

MARKMAKING

One of the many charms of watercolour is the variety of marks that a single brush is capable of making. Exploit the capabilities of one brush to the fullest before changing to a different one – a smaller brush, maybe – for final detail. Too many different brushes in one painting can make it look fussy, because each brush has its own character.

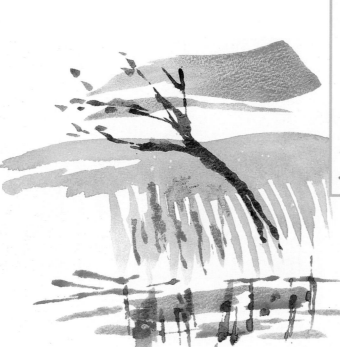

USING A 3.75 MM (1½ IN.) FLAT BRUSH

This size of brush can be used on its edge or with its full width. It is ideal for filling in large areas quickly or for drawing straight lines.

USING A LARGE, SIZE 20 BRUSH

A large round brush, such as a size 20, will make broad shapes and patches of colour without going into detail. These marks are ideal for suggesting a mass of colours, such as a carpet of flowers.

USING A SMALLER SIZE BRUSH

A smaller size brush, such as a size 8 or size 10, is good for more detailed work. Always use a brush with a fine point and plenty of body. Draw with the point and use more pressure for filling in.

MAKING NEGATIVE SHAPES

Create pale marks by painting the negative spaces between them. This is ideal for giving the impression of tree trunks or the petals on flowers.

STIPPLING

Use the point of the brush to make random brushstrokes. Allow some of the marks to merge. This is particularly effective for creating textures.

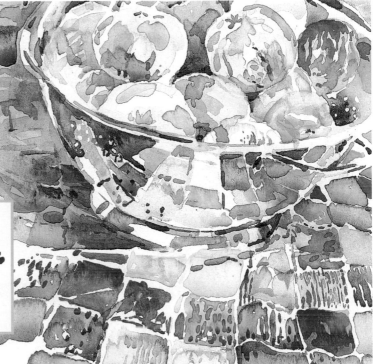

SEEING AND THINKING IN LAYERS

In the following picture-analyses, the paintings have been broken down into layers showing the thought processes behind each one. Thinking ahead is particularly important in watercolour whatever the subject, be it portrait, still life or landscape.

LANDSCAPE

The challenge in painting a landscape is posed by the distances involved. The composition needs to be planned into distant, middle ground and foreground areas.

THE SCENE
Autumn in Alaska: a clear light illuminates a lake surrounded by reeds. The eye is drawn to a distant glacier.

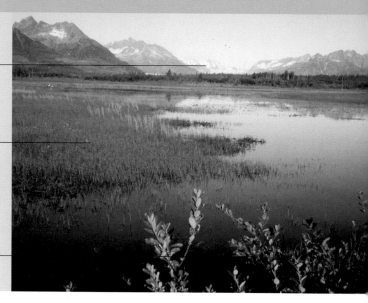

Glacier: the point of interest.

Great expanse of golden reeds.

Bushes will be ignored in the painting.

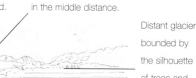

The position of patches of snow, which describe the slope of the hillside, are noted.

Parallel lines give recession in the middle distance.

Distant glacier bounded by the silhouette of trees and shadow in the snowcapped mountains.

Plenty of space is allowed for the reeds.

THE DRAWING The composition is worked out. Sufficient space must be left for the glowing colour of the reeds in the foreground, the parallel lines of the water and reeds in the middle ground and the detail around the glacier in the distance.

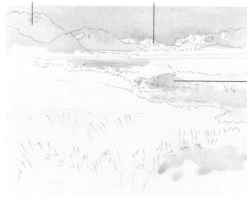

Blue is continued over the hills in the middle distance.

A cool, cerulean blue sky shows up the snowcapped mountains.

The water is painted with cerulean blue to reflect the sky; white areas are left for the reflection of the mountains.

LAYER 1 The sky around the distant snowcapped mountains is painted with cerulean blue. The wash is also painted across the hills in the middle distance and into the reflections in the water.

Untouched paper for patches of snow.

A mixture of raw sienna and cerulean blue describes the hills of the middle distance.

Pure raw sienna is used for the parallel lines of the middle distance.

A rich wash of pure raw sienna for the reeds.

LAYER 2 In warm contrast to the cerulean blue, raw sienna is used for the reeds. With the addition of a little cerulean blue, the mix is used to paint the hills in the middle distance, omitting areas for patches of snow.

Cerulean blue with raw sienna and a touch of permanent rose for the trees.

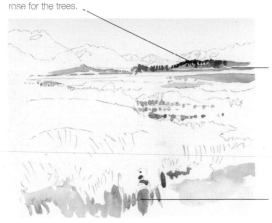

Ceruloan blue with raw sienna makes green for the shore in the middle distance.

Cerulean blue mixed with a tiny amount of permanent rose.

LAYER 3 Burnt sienna is introduced to bring the nearest hills closer and to warm up the foreground by suggesting the form of the reeds – these are painted wet into wet over the raw sienna.

Burnt sienna with cerulean blue for the near hills.

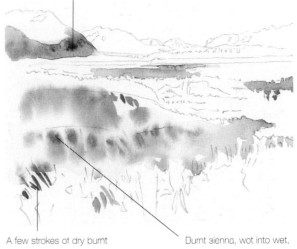

A few strokes of dry burnt sienna delineate the foreground edge of the reeds.

Burnt sienna, wet into wet, suggests the height of the reeds.

LAYER 4 The line of trees is blended into the hillside but sharply silhouetted against the glacier. This brings focus to the glittering distance. The near water is darkened and warmed with cerulean blue touched with permanent rose.

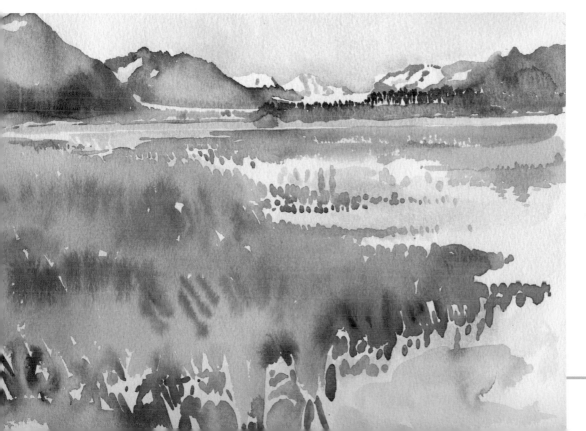

THE FINISHED PICTURE
The impact of this picture lies in the contrast between the cool blue of the sky and water, and the golden glow of the reeds. The viewer's interest has been focused on the distant glacier gleaming in the sun.

PORTRAIT

Don't be afraid of painting a portrait in watercolour. Observe carefully and look for drama in the face. Then paint as simply as you can.

THE SUBJECT The drama here is in the high forehead and the cheekbone, the set of the head and the kindly features. Lighting from above emphasizes the crown, the cheekbone, the ridge of the nose and the lower lip.

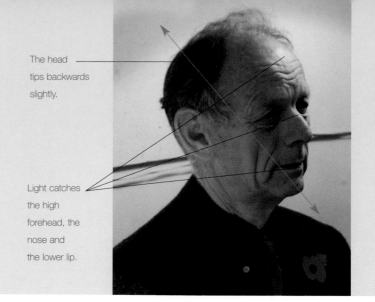

The head tips backwards slightly.

Light catches the high forehead, the nose and the lower lip.

The hairline is noted.

The skull shape is suggested.

Space for the eyes to look across.

THE DRAWING A simple but careful drawing places the head on the page, allowing space for the sitter to gaze into. Making an initial drawing gives you the confidence to paint freely, guided but not ruled by the pencil lines.

LAYER 1 Green gives good shadow tones in flesh. Here a mixture of viridian green touched with scarlet lake is used to show up the shape of the skull and plot the highlights.

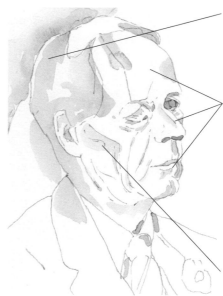

Viridian green with a very little scarlet lake makes a grey-green.

Highlights on the brow, nose and lower lip are shown up by the dark areas alongside them.

The cheekbone is delineated.

The flesh colour is mixed from scarlet lake and aureolin yellow.

When the flesh colour is painted over the green, it makes a warm grey.

A stronger wash is used for the tie.

LAYER 2 A thin wash of a mixture of scarlet lake and aureolin yellow gives a good flesh colour. Painted over the green wash, it warms the shadows and darkens the hair and jacket.

LAYER 3 Aureolin yellow is used lightly in the background, which highlights the left eyelid, suggests the glow of light and, at the same time, reduces the stark white of the paper.

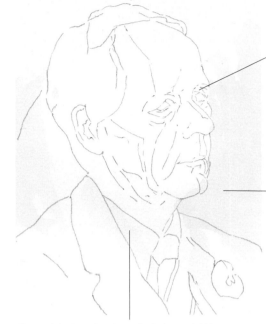

The highlight on the eyelid is shown by the yellow paint up against it.

The glow of light is suggested and the whiteness of the paper is lost.

The wash is also painted over the jacket and shirt.

A thin mix of viridian green with a touch of scarlet lake is used for the shadow behind the head.

A richer mix, with more scarlet, is used for the hair and to give depth to the eyes.

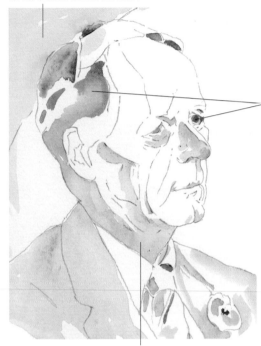

With still more scarlet, the same combination is used for the darker flesh tones.

LAYER 4 By using combinations of the same colours, in a richer mix, modelling is added to the portrait without going into too much detail.

THE FINISHED PICTURE
On the cheek, the layers of different washes can be clearly seen. The mouth has been modelled: the lower lip has been left light, and dark shadow has been painted on the far cheek. Rather than attempting to match colours precisely, watercolour washes have been used simply and imaginatively to suggest the hues of the sitter's head and clothes.

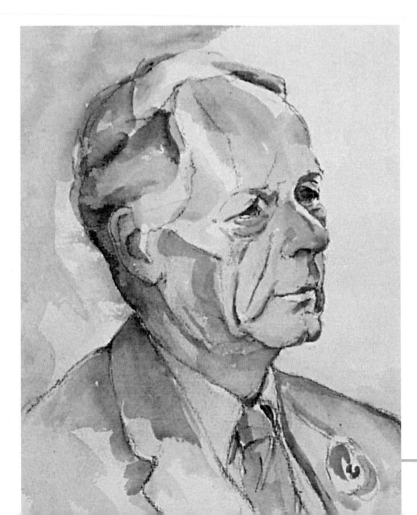

STILL LIFE

Painting a still life is fun to do. With a simple subject, you can try out techniques and theories discussed earlier in this book.

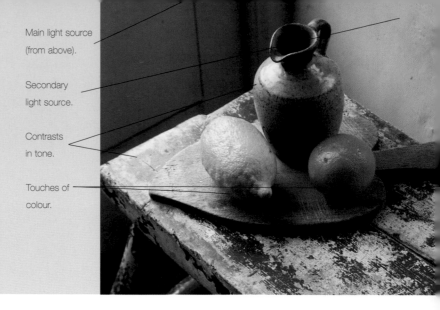

Main light source (from above).

Secondary light source.

Contrasts in tone.

Touches of colour.

THE SET-UP This simple still life was set up in a corner, with light coming through windows to the left and right. The strength of the composition lies in the tonal pattern, which is enlivened by the colour of the lemon and the clementine.

Elevated view creates a good shape inside the mouth of the jug.

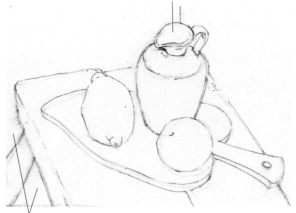

The background is broken up into positive shapes.

THE DRAWING The drawing works out the composition, and the elevated viewpoint makes the spaces more interesting. The whole page is broken up into shapes that fit together like a jigsaw puzzle.

Two layers of paint deepen the tone here.

The stool top and highlight on the jug are left unpainted.

A lemon yellow wash is painted over the jug, fruit and cutting board.

LAYER 1 A mixture of viridian green and a small amount of permanent rose is used to lay in the tonal pattern. These colours are chosen because they make a neutral tint; they will also reappear in the painting – the green in the stool and the permanent rose in the orange of the clementine.

By painting in the background, the light falling on the subject is created.

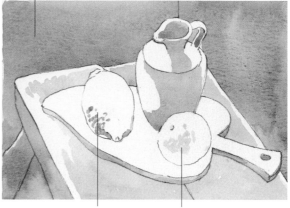

The lemon is left unpainted apart from a little shadow.

The clementine is left unpainted except for a little modelling.

LAYER 2 Lemon yellow is used throughout the picture. It is suitable for the lemon, will make orange (with permanent rose) for the clementine and is integral to the colour of the wood cutting board and that of the stone jug.

LAYER 3 A very dilute wash of permanent rose is painted over everything but the lemon, stool and highlights. This deepens the tones and adds colour to the clementine. At this stage, the clementine and the cutting board are the same colour.

The lemon remains yellow and paler in tone than the other objects.

The clementine and the cutting board are both pale orange at this stage.

As more paint is added with each layer, an impression of depth inside the jug is achieved.

More yellow, applied wet into wet and touched with permanent rose, strengthens the orange of the clementine.

LAYER 4 The stool and the cutting board are washed with diluted viridian green, creating the wood colour of the board and giving colour to the stool. The lemon is formed with strong lemon yellow The clementine is also formed with lemon yellow and then touched with permanent rose, wet into wet. A hint of permanent rose is also added to the jug, giving it some warmth.

Additional yellow on the lemon gives it form.

A wash of viridian green over the cutting board makes the wood colour and keeps the board darker in tone than the clementine.

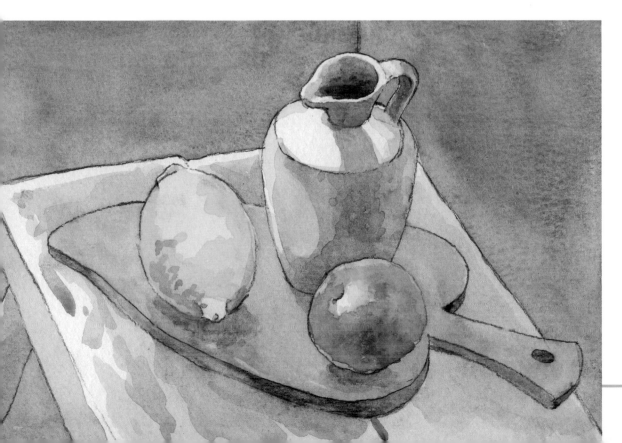

THE FINISHED PICTURE

All the tones are in the correct relationship to each other, from the highlights on the stool and the jug to the darkness inside the jug. The lemon and the clementine are brightly coloured, but the clementine is a tone darker than the lemon.

49

PAINTING PALE FLOWERS WITH A BACKGROUND

Painting pale flowers by building up a background is an exercise in painting in 'negative' – using the surroundings to give form to the pale shapes.

THE SUBJECTS

The primroses are arranged as naturally as possible, note how the flowers shine out from a muted background. The frilly petals and shapes of the sunflowers are defined by the rich background wash.

The primroses are bright against the background.

The leaves and the surroundings are similar in tone.

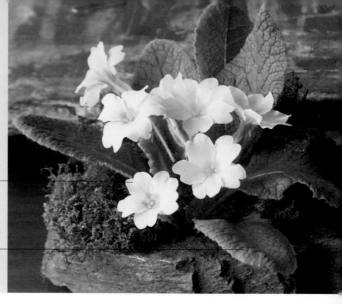

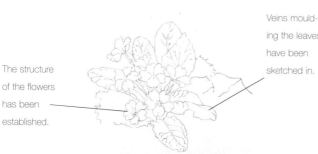

The structure of the flowers has been established.

Veins moulding the leaves have been sketched in.

THE DRAWING The flowers have been carefully observed, noting the number and arrangement of the petals and the tilt of the flower-head ellipses.

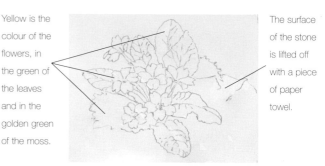

Yellow is the colour of the flowers, in the green of the leaves and in the golden green of the moss.

The surface of the stone is lifted off with a piece of paper towel.

LAYER 1 As there are no shiny highlights, a lemon yellow wash can be painted over the whole picture.

LAYER 1 Draw the outlines of the flower arrangement lightly with a soft pencil. Wet the picture surface with clean water. While the paper is still damp apply loose washes of pale blue, violet and yellow to the background, then pale yellow to the flowers and leaves. Allow to dry completely.

Wet the entire surface of the picture before adding washes.

Work carefully around the shapes of the sunflower petals.

Lively gradations of colour are created by the wet in wet technique.

LAYER 2 Define the middle values of the leaves with sap green and Prussian green. While these first washes are still damp, drop into them some blues, golds and violets. Allow the painting to dry.

LAYER 3 Mix separate washes of blue and violet in your palette. Sweep in broad, loose strokes across the upper right-hand corner of the picture. Vary the washes by allowing the two colours to mix together on the paper. Allow a thin wash of violet to overlap the flower on the left-hand side, which is in shadow.

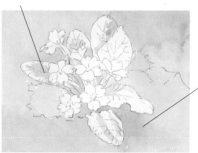

The application of blue around the flowers makes them stand out.

Blue painted over the yellow gives a soft green.

LAYER 2 A thin wash of cobalt blue is painted over the background and the shadows in the leaves, giving form to the shapes of the flowers.

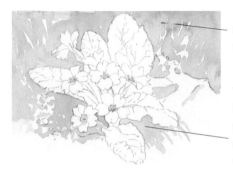

Orange warms up the background.

The use of orange has been suggested by the golden green of the moss and it differentiates the moss from the leaves.

LAYER 3 An orange made from lemon yellow and scarlet lake is washed over the background, apart from the stones. The same mixture, with extra yellow, is used for the flower centres.

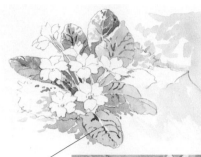

LAYER 4 The leaves are built up with a green made by mixing lemon yellow and cobalt blue. In light areas, the yellow prevails; in darker areas, more blue is used.

Pale green (a mix with more yellow) defines the lighter parts of the leaf with the veins painted dark.

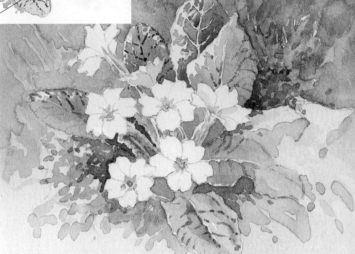

THE FINISHED PICTURE
The primroses glow against the muted background, and the leaves blend into their surroundings, which are similar in tone. A very dilute wash has given shadow to the underside of the flower.

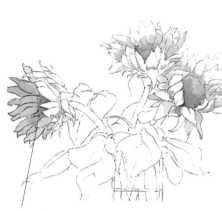

When dry, add further layers of colour to suggest deeper shadows.

Leave thin slivers of white paper to suggest the veining on the leaves.

LAYER 4 Start to define the shapes of the sunflower heads by modelling with light and shade. Mix a warm, golden yellow and paint the centres of the flowers and the shadowed petals. Mix a cool, transparent shadow tone of blue and violet and wash this over the petals of the left-hand flower, which is in deeper shade.

LAYER 5 Now start to define the forms of the leaves with more overlay washes. Mix a variety of greens, blues and violets, both warm and cool. Keep the washes thin and transparent and apply wash over wash. Observe which parts are in shadow and which face the light and paint them warm or cool accordingly.

THE FINISHED PICTURE To emphasize the colours of the sunflowers, the background needs to be made darker with further washes of blue, green and violet. Using the same blues and greens, the leaves on the shadow side of the arrangement have been darkened. Final touches of dark, cool shadow colours are applied with the tip of the brush.

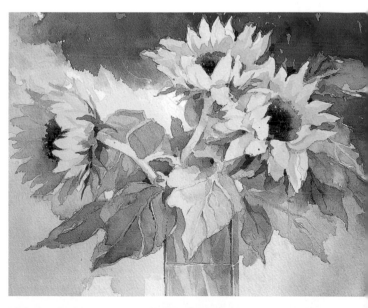

PART TWO

EXPLORING THEMES

On the following pages, you will find 12 different paintings that have been broken down into layers to help you follow the way each one has been constructed. There is no right or wrong way to create a painting; every artist is unique and develops techniques that suit his or her particular vision.

RESERVING WHITE PAPER

by JANE LEYCESTER PAIGE

In this picture, the white of the paper is used as an integral part of the painting: the white shapes in the composition are as important as the dark or coloured ones. The light coming through the window highlights the shine on the bowl and reflects back off the terracotta tiles. A single brush is used throughout the painting – a size 14 sable.

1 ESTABLISHING THE WHITE AREAS OF THE PAINTING

Underpaint with aureolin yellow, leaving white only for the paintwork of the window frame, the highlights on the fruit and bowls and the uplit grouting in the foreground.

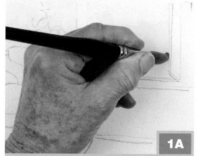

Paint the window-panes, leaving the frame white.

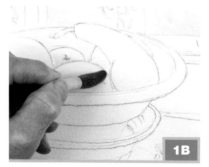

Paint aureolin yellow across the fruit.

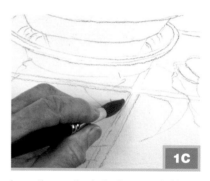

Leave the grouting in the foreground white.

MATERIALS

Paints
- Aureolin yellow
- Cobalt blue
- Scarlet lake
- Viridian green

Paper
- Rough, 300 gsm (140 lb.)

Brushes
Size 14 sable

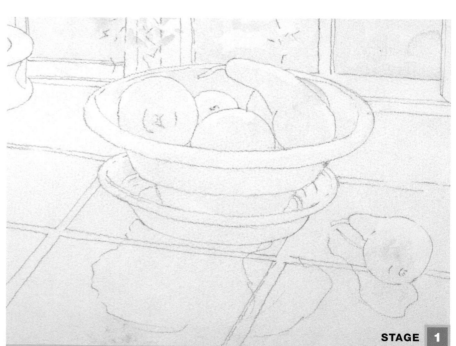

STAGE 1

The lightest areas of the picture have been left white.

STAGE 1

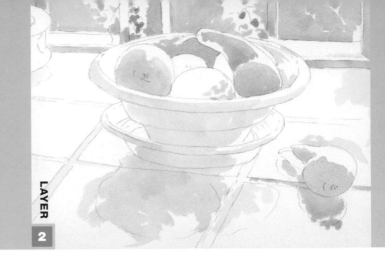

2 LAYING IN THE TONAL PATTERN WITH BLUE

Using cobalt blue, block in all the shadows, treating the side of the bowl and its shadow on the tiles as one continuous, soft-edged shape. Give the shadowed interior of the bowl a crisp edge to define the shape of the fruit.

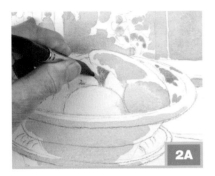

2A

Paint a dark, crisp-edged shadow for the interior of the bowl to reveal the shape of the fruit.

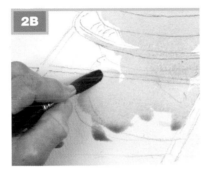

2B

Make the shadow on the bowl and tiles soft-edged.

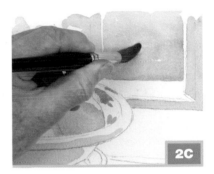

2C

Paint blue over the yellow to suggest green.

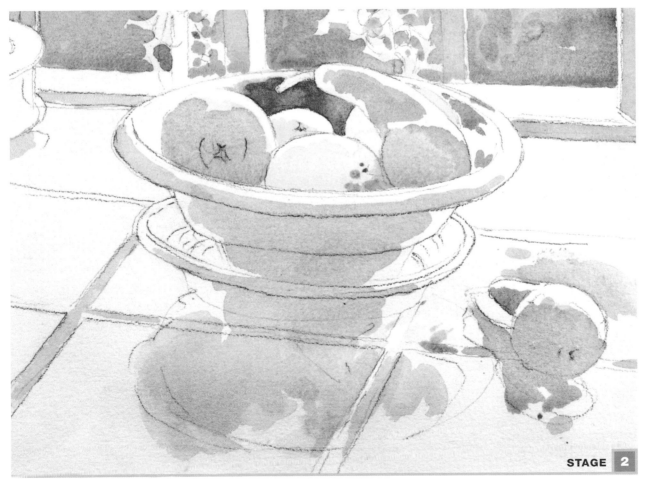

STAGE 2

The shadows have been laid, and the tonal pattern emerges.

STAGE 2

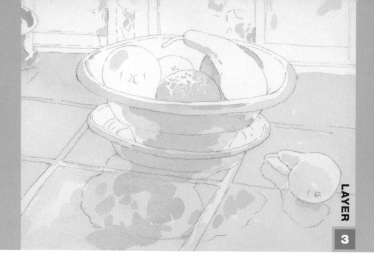

3 ADDING RED TO THE PAINTING

Use scarlet lake for this layer. Red is always a dominant colour and needs to be applied lightly when used as a wash. Suggest the colour of the terracotta tiles, reflecting light from the window, by using the red thinly (with more water) over the pale yellow. Introduce the red (with less water) into the shadow on the bowl and tiles to give warmth to the terracotta.

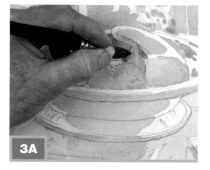

3A

Apply red over the yellow to make the colour of the oranges.

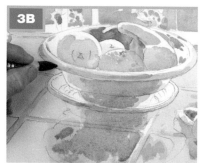

3B

Pick out the rim of the bowl.

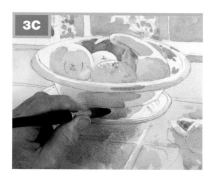

3C

Apply more red, wet into wet, to the underside of the bowl and shadow to give form and warmth.

STAGE 3 The warmth of the terracotta tiles has been established.

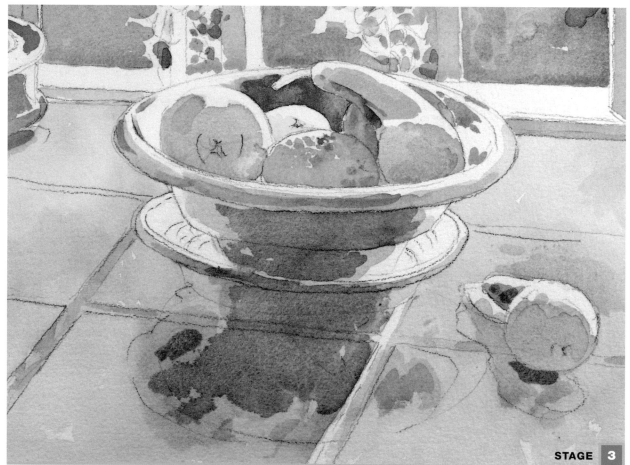

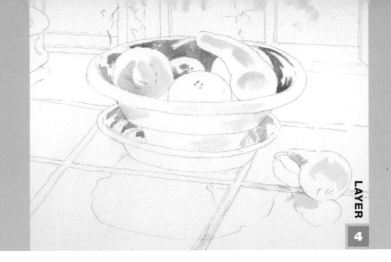

ENHANCING THE GREEN

4 Use viridian green mixed with aureolin yellow to paint in the bright, shiny green of the inside of the bowl. (The white highlights also help to indicate the shape of the bowl.) Add more aureolin yellow to the viridian green to make a pale green. Wash this over the pears and apples, and use it to add freshness to the foliage seen through the window.

4A

Mix viridian green with aureolin yellow to paint inside the bowl, around the fruit.

4B

Paint the curved, shiny surface of the inside of the saucer.

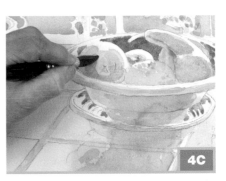

4C

Add more aureolin yellow to the viridian green and use it to form the pears and apples.

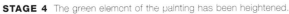

STAGE 4 The green element of the painting has been heightened.

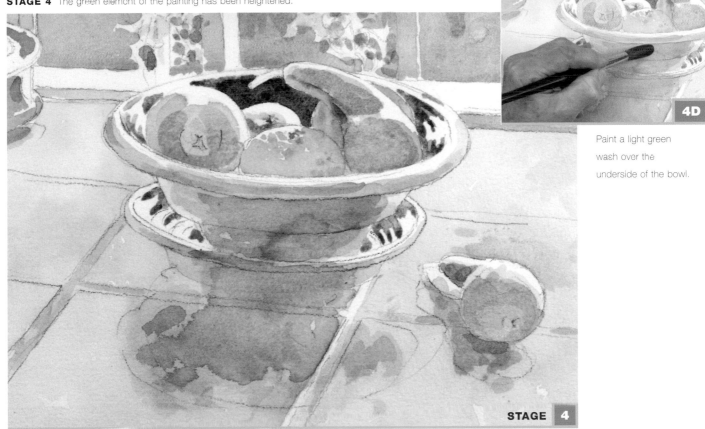

4D

Paint a light green wash over the underside of the bowl.

STAGE 4

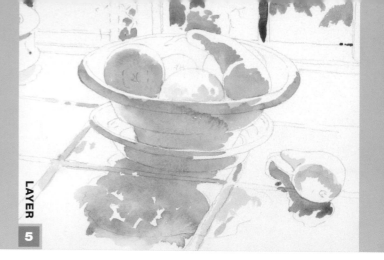

5 DEEPENING THE SHADOWS

Now strengthen the shadows. Mix viridian green and scarlet lake to achieve greys that are in harmony with both the fruit and the terracotta tiles. For the fruit, the mixture should contain only a little scarlet. Paint the glazing bars in the window with the same mixture but using less water; this will give a darker tone. For the terracotta, add more scarlet to the mixture.

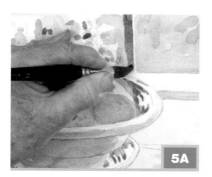

5A

Paint the glazing bars in the window with a strong mixture of viridian green plus a little scarlet lake.

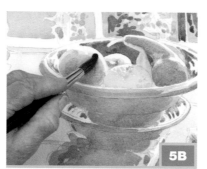

5B

Add more water to make a paler, more greenish grey, and apply it to the fruit.

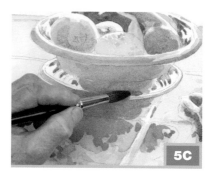

5C

Add more red to the mix to make a warm grey, and use it for the bowl and the shadows.

STAGE 5 With deeper shadows, the painting has more depth, and the backlighting from the window is suggested.

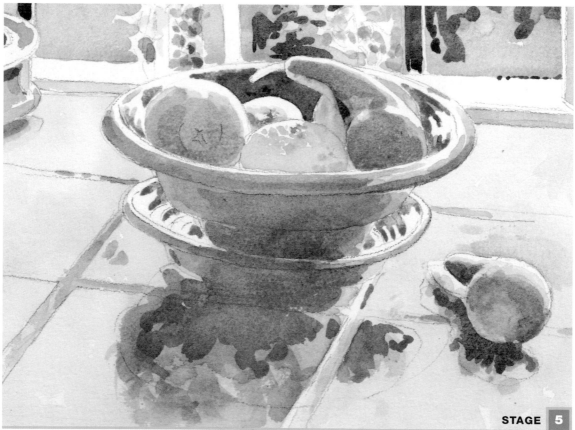

STAGE 5

6 THE FINAL DETAILS

Heighten the colours and tones and deepen the shadows, using mixes of the colours already used in the painting. Suggest coolness on the tiles behind the lone pear, leading towards the window, with a mixture of cobalt blue and a very little scarlet lake. Add more warmth to the foreground with a mixture of scarlet lake and aureolin yellow. Paint the pear stalks with a strong mix of scarlet lake and viridian green. Add texture to the orange.

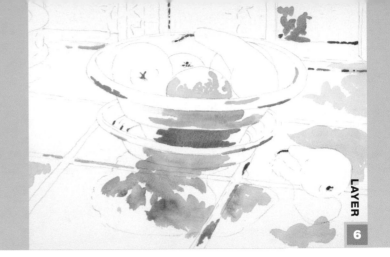

6A

Use a mixture of viridian green and scarlet lake (with a little water) for details around the window.

6B

Strengthen the underside of the bowl and its shadow with a mixture of scarlet lake and aureolin yellow.

6C

Add form to the orange with a mix of scarlet lake and aureolin yellow.

STAGE 6 The finished painting.

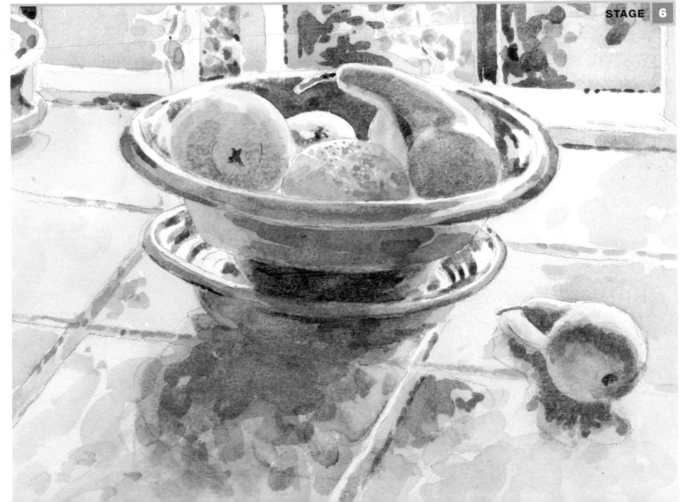

STAGE 6

PATTERNS IN NATURE

by JANE LEYCESTER PAIGE

The subject of this painting is a clump of dainty dog's tooth violets, with big, glossy leaves unfurling in the spring sun. A contrast in shape – though not so much in colour – is provided by the tough, sturdy leaves of the hellebore and the long, strappy leaves of the iris.

Use crisp contrasts to describe the sunshine. A dark background, full of warm reds and browns, will help give a three-dimensional appearance to the leaves and flowers.

Use a limited palette of primary colours, together with viridian green and dioxazine violet.

1 ESTABLISHING THE PATTERN AND SHAPE OF THE LEAVES AND FLOWERS

Use the size 16 brush (with a good point). Make up a light wash of aureolin yellow touched with cobalt blue for the leaves. (Make sure that you leave out the shapes of the flowers.) Vary the wash slightly for different leaves by adjusting the amount of blue used.

1A

Create the shape of the dog's tooth violet flower by painting the leaf behind it.

1B

Vary the amount of blue in the wash for different leaves.

1C

Leave out the areas of highlight on the leaves.

MATERIALS

Paints
- Aureolin yellow
- Cobalt blue
- Scarlet lake
- Viridian green
- Dioxazine violet

Paper
- Rough, 300 gsm (140 lb.)

Brushes
- Size 16 synthetic
- Size 10 synthetic

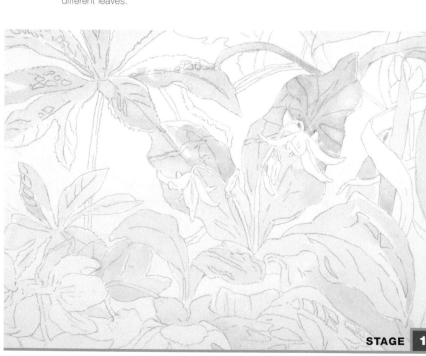

STAGE 1
The composition has been established.

STAGE 1

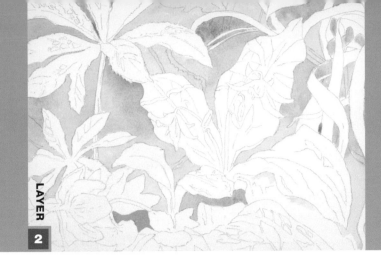

2 PUTTING IN THE BACKGROUND

For the first background layer, use a wash of cobalt blue with a tiny amount of scarlet lake. This makes a subtle blue-grey with a hint of warmth. Paint the iris with almost pure cobalt blue. At this stage, the whole painting is more or less even-toned, except for the flowers and highlights.

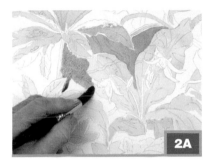

Paint in the negative spaces with the blue grey wash.

Paint in the iris with cobalt blue.

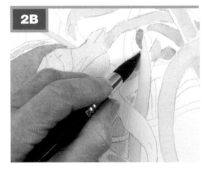

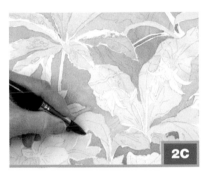

Where the blue-grey is laid over the green, areas of shadow begin to appear.

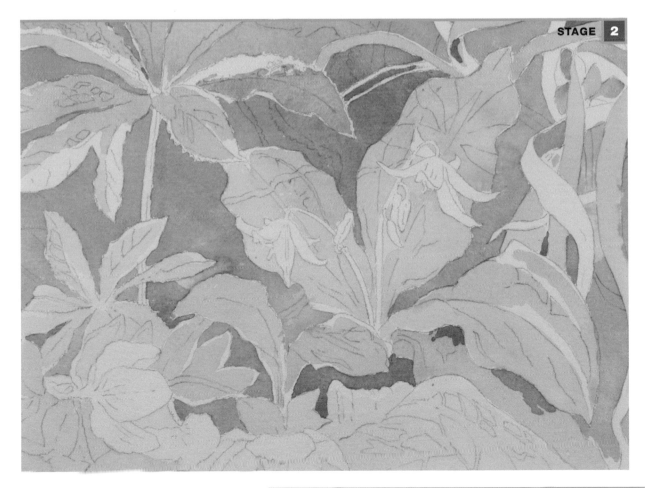

STAGE 2

STAGE 2

The background has been established.

3 DEEPENING THE TONE OF THE BACKGROUND

Make a warm, orange wash using scarlet lake and aureolin yellow. Paint it over all the background, except for some parts of the dead leaves. The orange over the blue will create a warm grey-brown. Because the background now has two layers of wash, it is darker than the leaves, making them stand out in the light. Lightly paint in the flower stems with the orange mix.

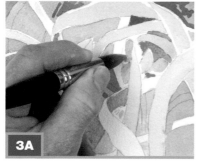

Paint the orange wash over the background. (The blue of the iris will be enhanced by having its complementary, orange, painted close to it.)

Where the orange is washed over the blue, it will make a grey-brown.

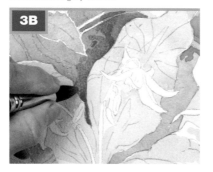

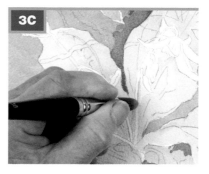

Paint the flower stems with the orange wash.

STAGE 3 The warm brown of the background has been created.

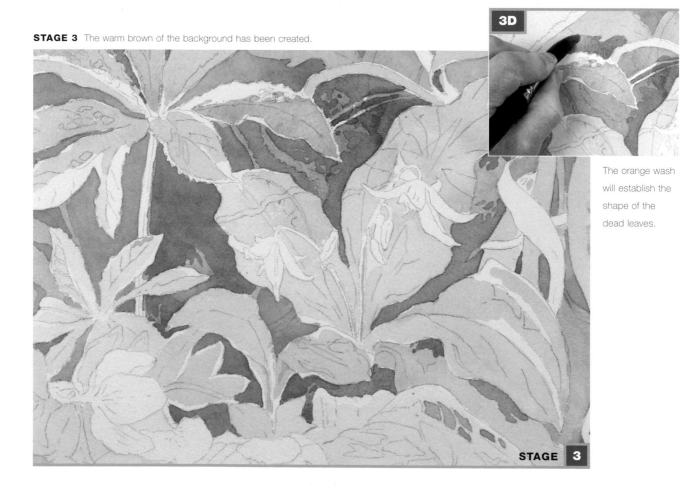

The orange wash will establish the shape of the dead leaves.

STAGE 3

4 GIVING FORM TO THE LEAVES

Make a rich green from aureolin yellow and cobalt blue with a little viridian green. (For different leaves, vary the wash slightly by using different amounts of each colour.) Use the size 10 brush (choose one with a fine point) to pick out details in different leaves and to paint in the darker parts of the leaves, including the shadow of the hellebore leaf across the leaf of the violet.

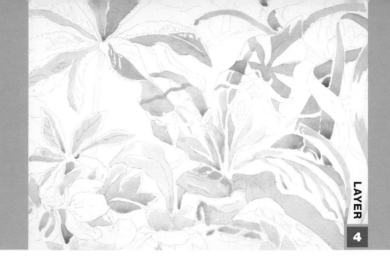

4A

Paint the shadow on the main leaf.

Paint the details on the hellebore leaves using varying strengths of the green wash.

4B

4C

Paint the details on the near leaf.

STAGE 4 The painting has begun to come to life, as the leaves have been developed.

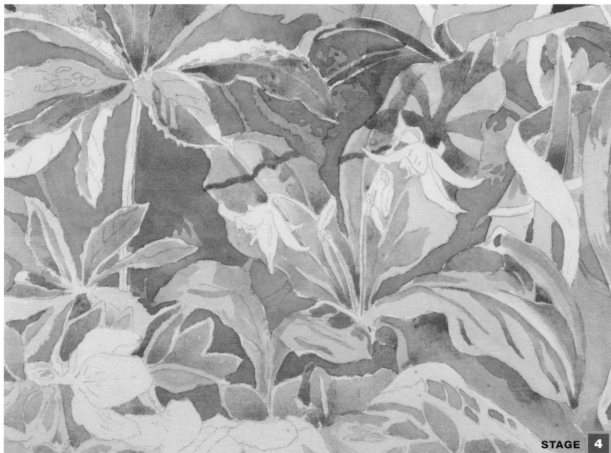

STAGE 4

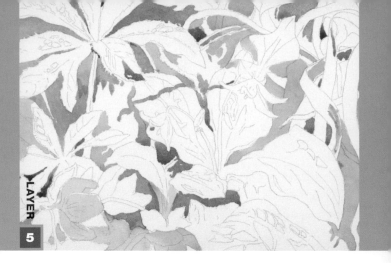
5 DARKENING THE TONE OF THE BACKGROUND

Now the painting becomes more lively. Use a varying mixture of viridian green and dioxazine violet to darken the tone of the background, making it warmer in some places and cooler in others. For the warmest-toned areas, add some scarlet lake to the mixture. Use the size 16 brush for this stage.

5A

Use a cool mix of viridian green and dioxazine violet behind the iris leaves.

Use a warmer mix (more violet, less green) to block in the hellebore flowers.

5B

5C

Create speckled light filtering through the dead leaves with dark shadows.

STAGE 5 The picture now has depth and form.

5D

Add more warmth to the hellebore flowers, using a little scarlet lake mixed with the dioxazine violet.

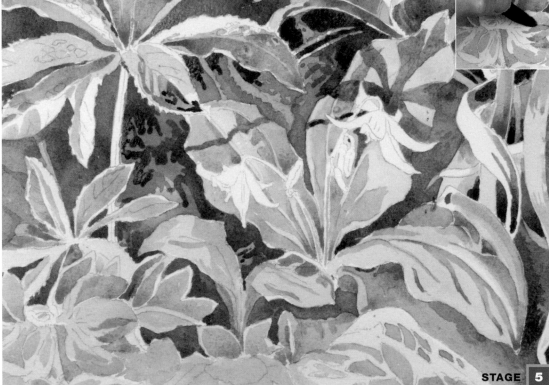

STAGE 5

6 THE FINAL DETAILS

Add details to the flowers and leaves. Use pure aureolin yellow to form the flowers. Paint the pistils with an orange mixture of scarlet lake and aureolin yellow. Paint the different stems with varying mixtures of scarlet lake and dioxazine violet. Use a blend of dioxazine violet and aureolin yellow for the inside of the hellebore flowers and dioxazine violet with scarlet lake for drawing in veins and stem wrinkles. Use the size 10 brush throughout.

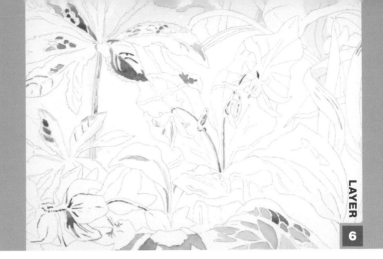

Add details to the flowers.

Pick out details on the iris leaves.

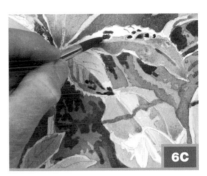

Refine the pattern of the hellebore leaf.

STAGE 6 The final image. The orange pistils of the hellebore have been defined with a mixture of scarlet lake and aureolin yellow.

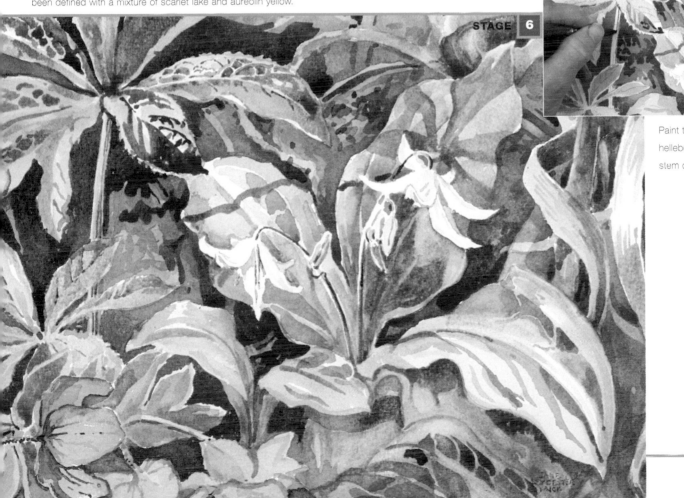

STAGE 6

Paint the hellebore leaf stem details.

CONTRAST IN THE LANDSCAPE

by PAUL TALBOT-GREAVES

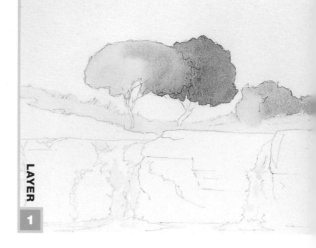

LAYER 1

The dramatic contrast between a waterfall tumbling over sheer rock and the lush green landscape above it makes an exciting subject. Late afternoon light helps to exaggerate tonal contrasts. The composition is carefully worked out and simplified before starting to paint. The technique is direct, and the colour is applied strongly, building the picture up one section at a time. As the painting dries, it is refined with the minimum of detail.

1 PAINTING IN THE LIGHTEST TONES

Paint the light tones of the foliage of the two trees first, with a mixture of lemon yellow and sap green. Then blend in French ultramarine and sap green to describe the side that is in shadow. Block in the grass with a mixture of sap green and raw sienna. Use diluted raw sienna to suggest the peaty water.

1A

Mix sap green and lemon yellow and paint the foliage of the trees with the size 8 brush.

Blend a mixture of sap green and French ultramarine into the shadow side of the foliage.

1B

1C

Mix sap green with raw sienna and use it to paint the grass.

MATERIALS

Paints
- Sap green
- Lemon yellow
- Hooker's green
- French ultramarine
- Payne's grey
- Burnt sienna
- Raw sienna

Paper
- 425 gsm (200 lb.)

Brushes
- Size 8 sable
- Old size 8 sable with blunt tip
- Size 5 sable
- Size 4 sable
- Rigger

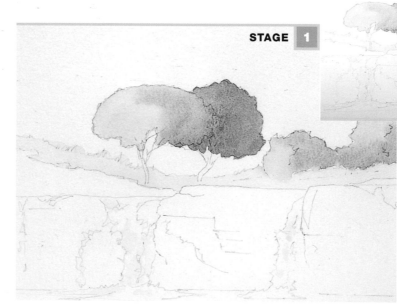

STAGE 1

1D

Make a dilute wash of raw sienna and use it to suggest the peaty water.

STAGE 1

The structure of the composition has been established.

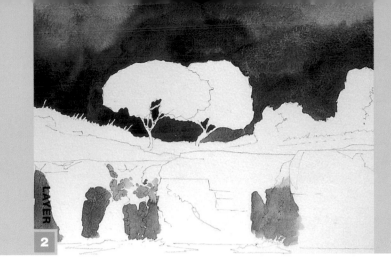

② CREATING THE WOODED HILLSIDE

When the first layer is dry, paint the dark trees of the background with pure Hooker's green and French ultramarine, blending them wet into wet, using the size 8 brush. Paint the shadows in the water at this stage too.

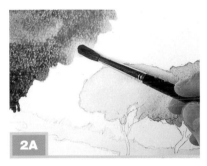

2A

Blend French ultramarine into Hooker's green in a broad wash over the background.

Define the light tree and the grasses with the edge of the wash.

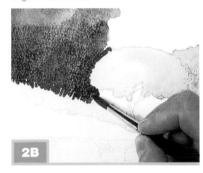

2B

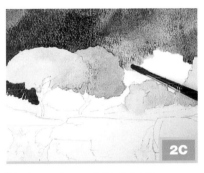

2C

Take the wash around the dark tree.

2D

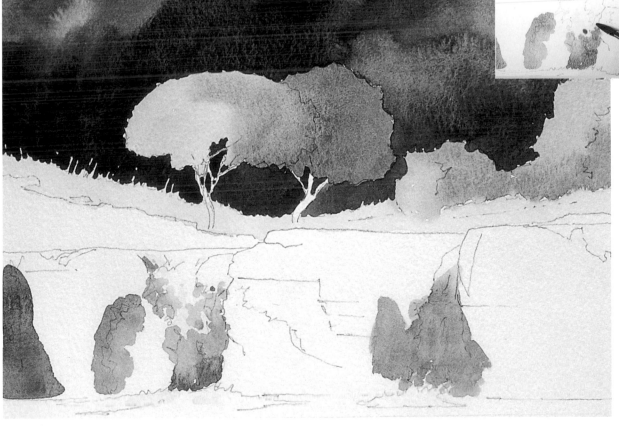

STAGE 2

Paint the shadows in the water with a mixture of Payne's grey and French ultramarine.

STAGE 2
The background trees are finished and the foreground is beginning to emerge.

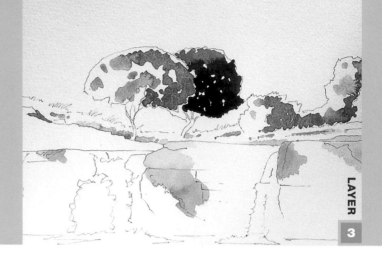

3 WORKING ON THE MIDDLE GROUND

In this layer, form the two middle-ground trees with stippling, and paint the lightest parts of the rocks. Use the size 5 brush and an old, blunt size 8 brush for stippling.

3A

Stipple the lighter trees with a mixture of sap green and French ultramarine.

Use clean water to soften and blend the edges.

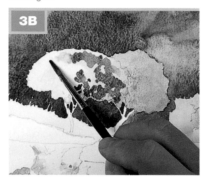

3B

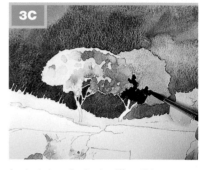

3C

Apply darker stippling to differentiate between the two trees.

3D

Make a mixture of burnt sienna and raw sienna and paint patches of light on the rocks.

STAGE 3 The green parts of the picture are finished. Work on the rocks has started.

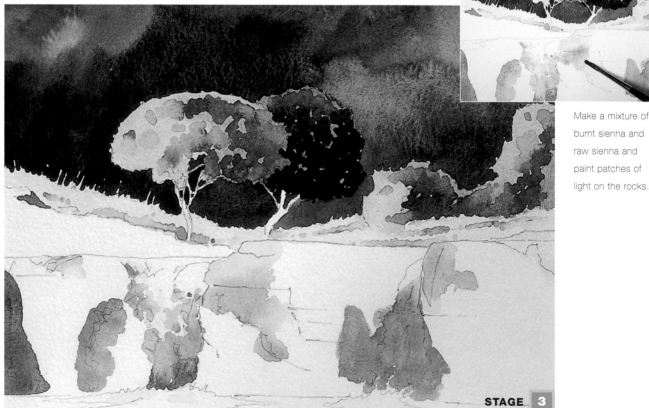

STAGE 3

4 PAINTING THE ROCKS

In this layer, paint the rocks, leaving negative spaces for the water. Use French ultramarine and burnt sienna, mixing them on the paper for underpainting. Then add them separately to the wet paint to enhance the intensity.

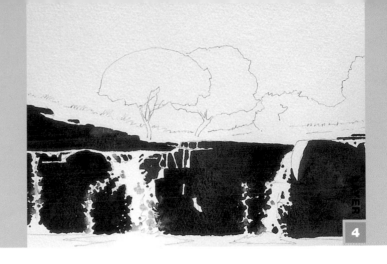

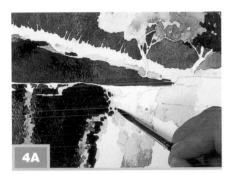

Stipple the waterfall with the blunt brush.

Paint the rocks with straight-edged sweeps of paint.

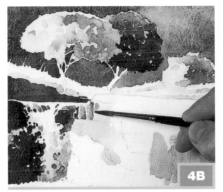

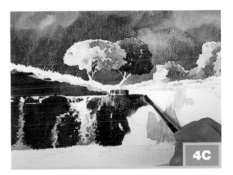

Add warmth to the rocks with pure burnt sienna.

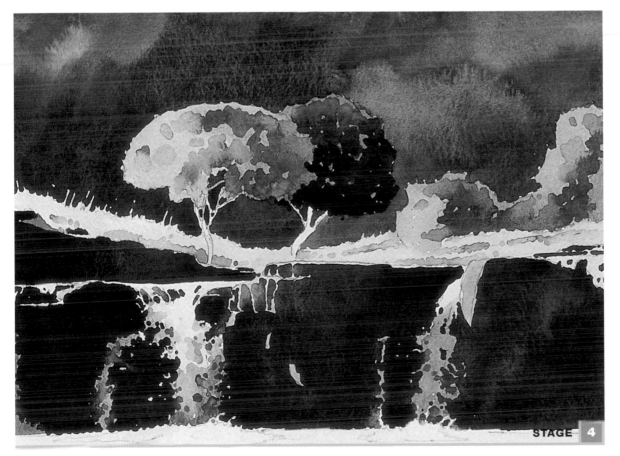

STAGE 4

A clear contrast between the soft foliage, the frothy, tumbling water, and the sharp, solid rock has now been established.

5 BUILDING UP THE ROCKS

Allow the painting to dry before doing more work on the rocks to increase the three-dimensional effect. Paint shadows on the pool below the waterfall. Use a combination of burnt sienna and French ultramarine throughout.

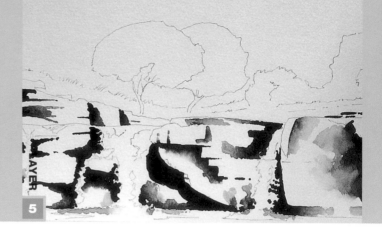

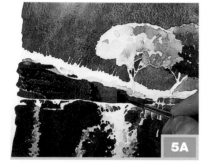

Add detail to the bank with the size 5 brush.

Create shadow behind the sunlit rock.

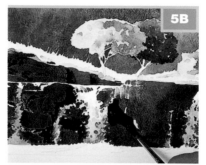

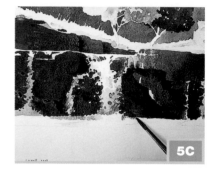

Paint shadow in the rock pool.

STAGE 5 The picture is nearly finished. The fine detail in the rocks, although very close tonally to the bulk of rock, is enough to suggest some structure and give a sense of a third dimension.

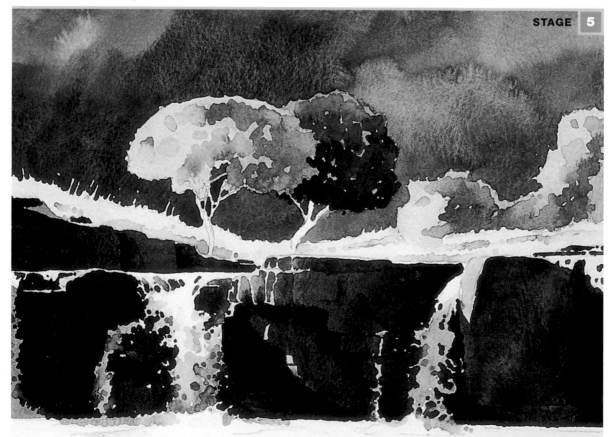

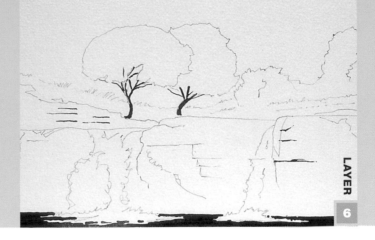

6 ADDING THE FINAL DETAILS

Apply the finishing touches to the trees and rocks and complete the painting of the pool. Use a mixture of French ultramarine and burnt sienna throughout.

LAYER

6

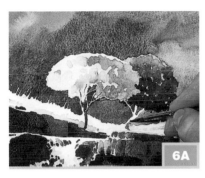

6A

Paint the tree trunks with the size 4 brush, leaving one side white where sunlight strikes it.

Paint the branches with the rigger.

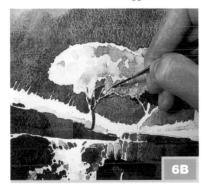

6B

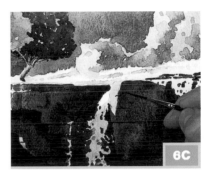

6C

Use the rigger to paint the rocks.

6D

STAGE 6

Paint the rock pool with the size 5 brush.

STAGE 6

The finished picture. In the final touches, the tree trunks have been illuminated, the rocks given more detail and the rock pool in the foreground has been painted in, leaving a white froth at the bottom of the waterfall.

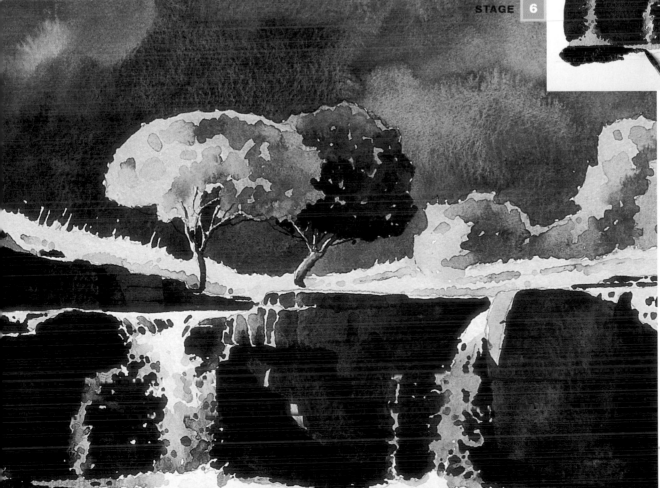

71

WASHES AND TONES

by NAOMI TYDEMAN

In this dramatic painting of Monument Valley, the heat and aridity are depicted through simplicity and a very limited palette. There is a balance of warm and cool washes and careful regard for tonal values. Only two mixes are used: one of new gamboge and Venetian red and the other of phthalo blue (red shade), dioxazine violet and Venetian red.

FIRST WASHES

Take a lilac-grey wash (phthalo blue, dioxazine violet and new gamboge) over the sky with the flat brush. Blend on the orange wash (new gamboge and Venetian red) over the distant cliffs. Then take a streak of orange into the sky, softening it with several strokes.

1A

Create a pencil sketch on watercolour board.

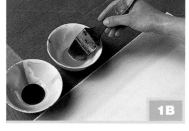

1B

Mix two bowls of colour for the washes, enough to complete the painting.

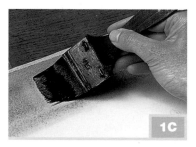

1C

Sweep the initial wash of lilac-grey across the board.

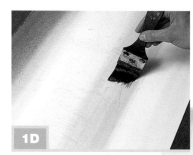

1D

Blend in the orange wash.

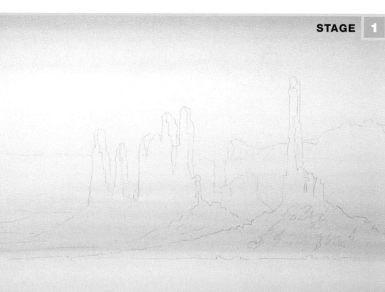

STAGE 1

STAGE 1

The initial washes have been applied.

MATERIALS

Paints

New gamboge

Venetian red

Phthalo blue (red shade)

Dioxazine violet

Paper

Watercolour board

Brushes

5 cm (2 in.) flat varnish brush

Sizes 3 and 7 round sable

Hair-dryer

2 DARKENING THE SKY

To darken the sky and increase the atmosphere, wash clear water over the lower part of the sky and add more of the lilac-grey wash to the top. Take the warm orange wash up and over the rocks to the clear water. Create texture in the foreground by dragging downwards with a dry brush.

LAYER 2

2A

Drag the orange wash downwards with the flat brush.

2B

Wipe surplus water from the edge of the board to prevent washbacks.

2C

Speed up the drying process with the use of a hair-dryer.

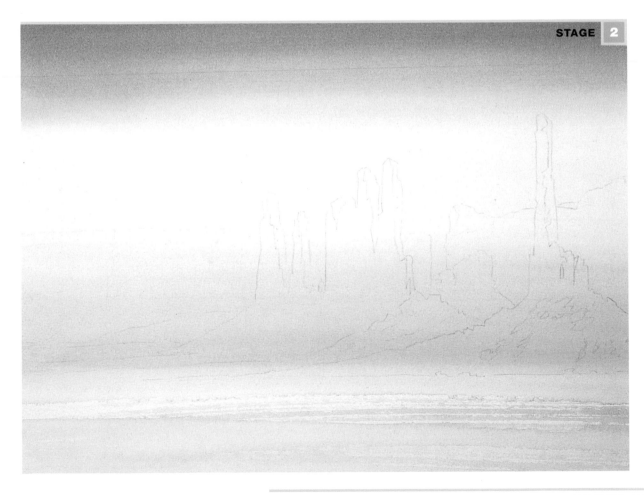

STAGE 2

STAGE 2

The initial washes have been intensified.

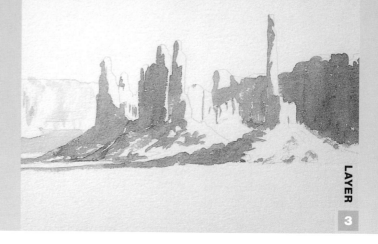
3 PAINTING IN THE SHADOWS

Use more of the lilac-grey wash to paint in the shadows with the size 7 round brush. Paint the distant cliffs with a diluted mix of the wash and use a darker mix for the foreground 'monuments'.

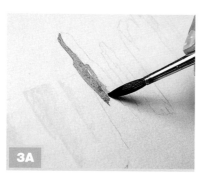

Paint the shadows of the rocks with the size 7 brush.

3A

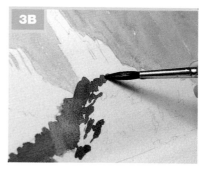

3B

Use a darker version of the shadow wash towards the foreground.

STAGE 3 The tonal structure of the painting is now established.

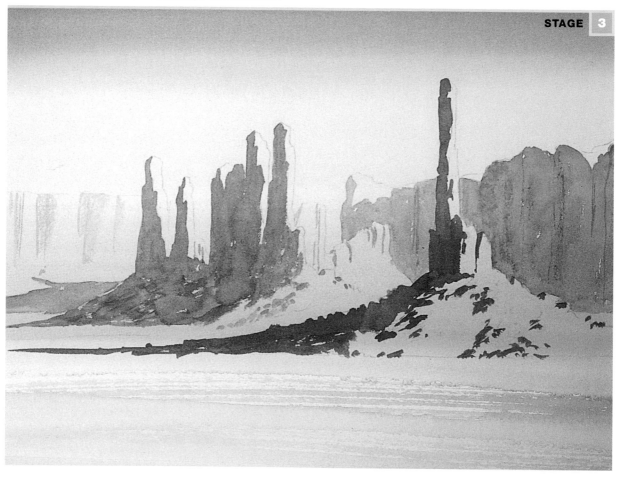

STAGE 3

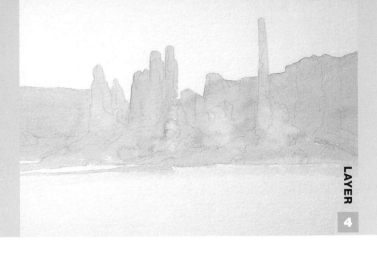

4 ADDING MORE WARMTH

Use the orange wash to paint over all of the rocks with the flat brush. Before this wash dries, quickly work up the 'fingers' of the rock that project above the line of the cliff. Drag this wash along the bottom of the painting into the elongated shadows of the 'monuments'.

Drag the orange wash over the rocks, foreground and distant cliffs.

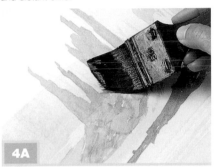

4A

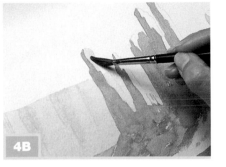

4B

Use the size 7 brush to drag the wash up the rock 'fingers'.

With a paper towel lift out some of the orange wash from the sunlit side of the nearest 'monument'.

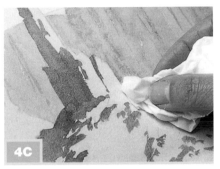

4C

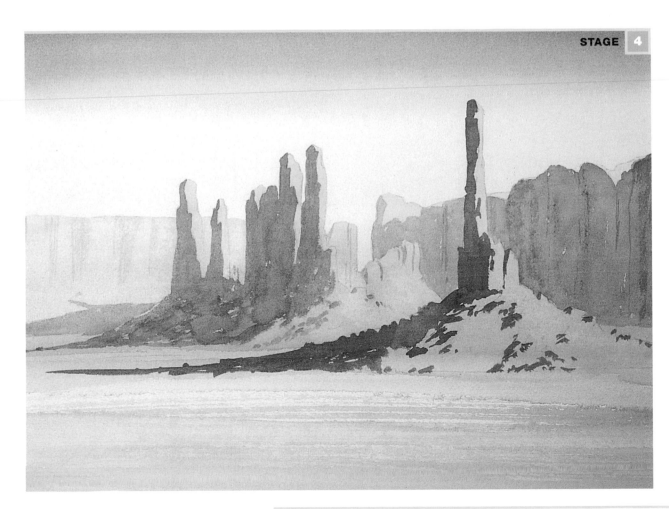

STAGE 4

STAGE 4
Greater tonal contrasts in the nearest 'monument' bring it forwards.

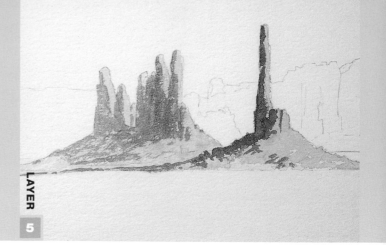

5 ADDING MORE FORM TO THE 'MONUMENTS'

Add more layers of orange to strengthen the colour towards the front of the painting. Increase the shadows towards the foreground. Then create texture on the rocks and some slopes using dry-brush techniques and the size 3 and size 7 brushes.

Add texture and detail to the foreground 'monument' by scumbling with a dry brush.

5A

STAGE 5 More form has been added to the foreground 'monument'.

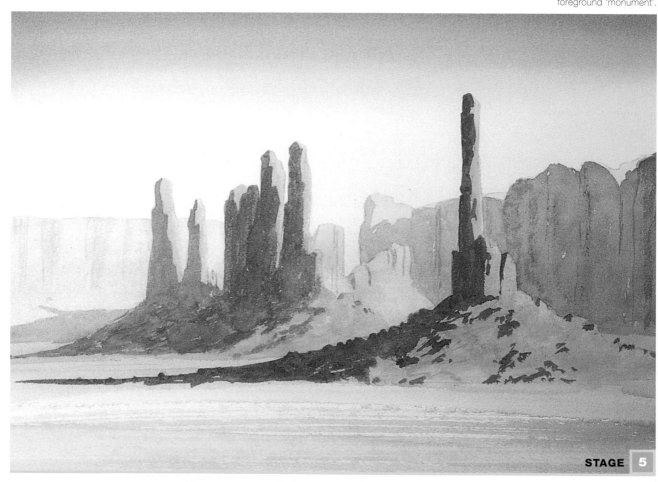

STAGE 5

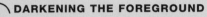

6 DARKENING THE FOREGROUND

Use the lilac-grey wash and a large flat brush to create shadow in the foreground.

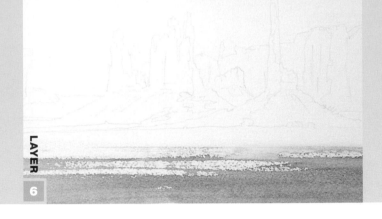

LAYER 6

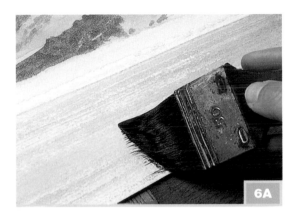

Sweep the undiluted shadow mixture lightly across the foreground, using a dry brush.

6A

STAGE 6 The depth of tone in the foreground helps the 'monuments' to stand proudly in their place as the focus of the composition.

STAGE 6

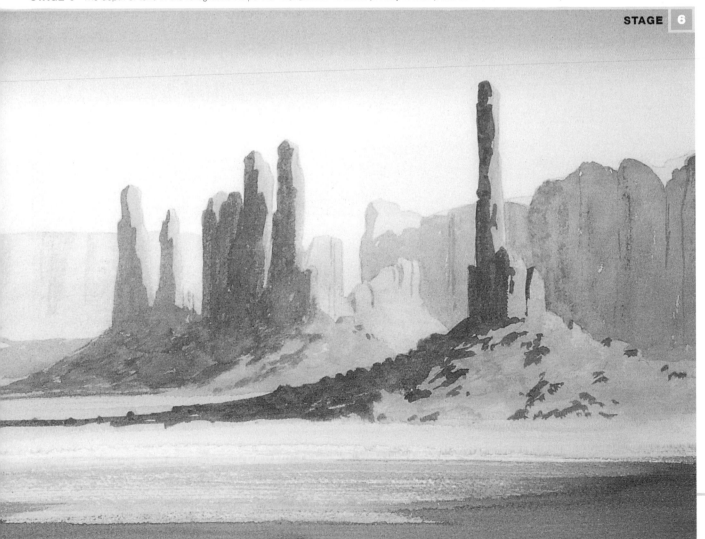

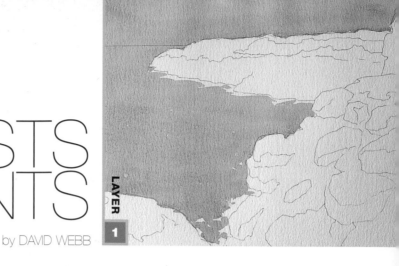

CONTRASTS IN ELEMENTS

by DAVID WEBB

The difference between two contrasting elements – sea (fluid) and rocks (solid) – makes a fascinating subject for a picture. With seascapes, it is often difficult to find a good foreground, but taking a high viewpoint allows the foreground rocks to 'frame' the wide bay and gives a high horizon.

The simple use of one natural-fibre brush, which has a good point and holds plenty of paint, gives uniformity to the painting.

MATERIALS

Paints
- Raw sienna
- Light red
- Alizarin crimson
- Burnt sienna
- Cobalt blue
- Phthalo blue

Paper
- Cold pressed, 300 gsm (140 lb.)

Brushes
Size 8 squirrel-hair mop

1 SETTING THE SHAPE OF THE COMPOSITION
Paint a wash of cobalt blue over the sky and sea, leaving a gap between the sea and the headland to indicate the surf.

Wash cobalt blue over the sky and sea.

1A

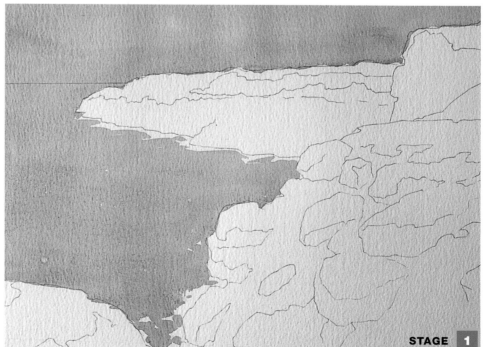

STAGE 1
The picture plane has been divided into land and sea/sky, establishing the shape of the composition.

STAGE 1

2 BREAKING UP THE LANDMASS

Suggest a sense of distance by using light red – dulled a little with cobalt blue – for the headland rocks; use light red on its own for the foreground.

Paint a wash of light red over the headland. Drop in a little cobalt blue, wet into wet.

Paint a pale wash of light red over the foreground rocks.

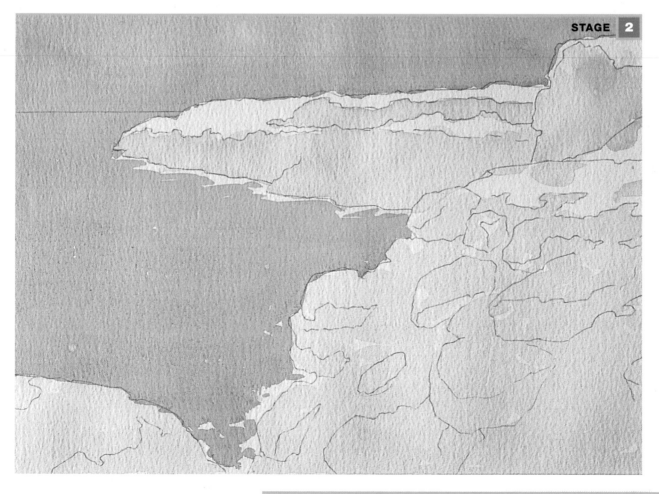

STAGE 2

STAGE 2
The underpainting has been completed.

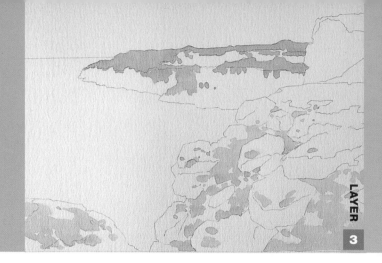

3 ADDING GREEN TO THE PAINTING

Use a mixture of raw sienna and phthalo blue to paint the headland. For the paler green within the near rocks, use raw sienna with only a touch of phthalo blue.

3A

Paint the headland with a green made from raw sienna mixed with phthalo blue.

3B

Paint between the near rocks with raw sienna mixed with only a touch of phthalo blue.

STAGE 3 Vegetation has been added to the land mass, providing texture that contrasts with the calm sea.

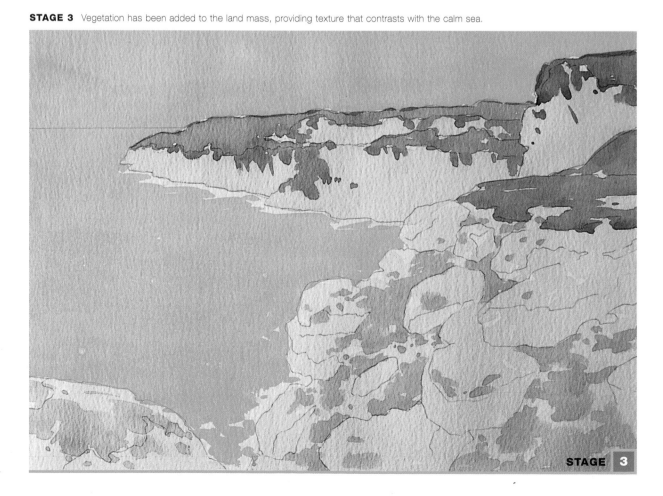

STAGE 3

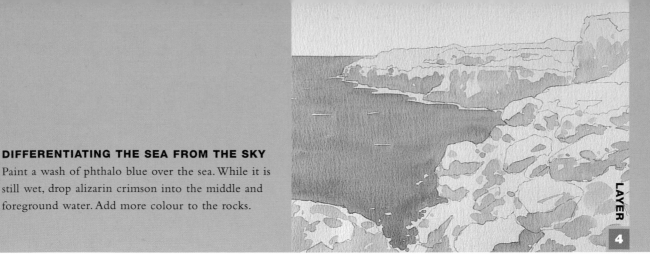

4 DIFFERENTIATING THE SEA FROM THE SKY

Paint a wash of phthalo blue over the sea. While it is still wet, drop alizarin crimson into the middle and foreground water. Add more colour to the rocks.

Add alizarin crimson to the wet phthalo blue.

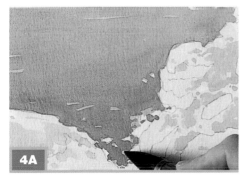

4A

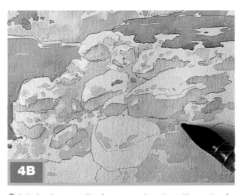

4B

Paint shadows on the foreground rocks with a mix of phthalo blue and alizarin crimson.

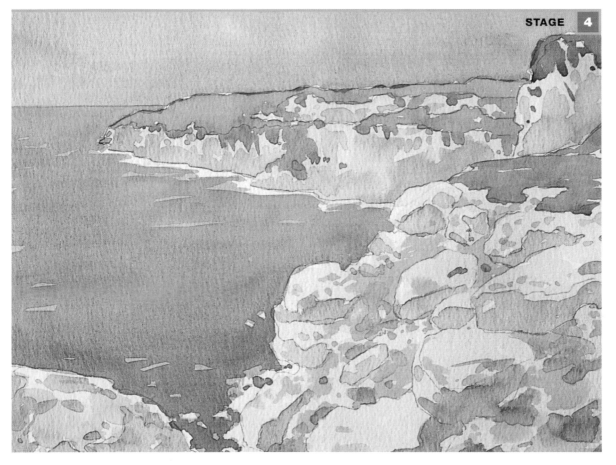

STAGE 4

STAGE 4

The sea has been painted, more colour has been added to the headland rocks, and some shadows have been painted in the foreground. A tonal balance has been preserved across the whole picture.

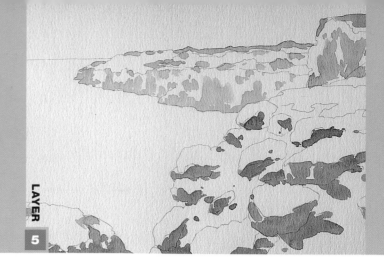

5 DEEPENING THE SHADOWS THROUGHOUT

With varying strengths of a mixture of alizarin crimson and phthalo blue, paint both the distant cliffs and the shadows on the near rocks. Use a dilute mixture for the cliffs and a stronger mix for the foreground.

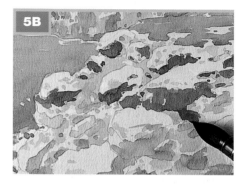

Paint the shadows on the foreground rocks with a stronger mix of alizarin crimson and phthalo blue.

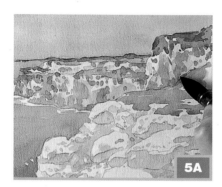

Paint the shadows on the distant cliffs with a dilute mix of alizarin crimson and phthalo blue.

STAGE 5 More form and distance has been created by deepening the shadows in the correct tones.

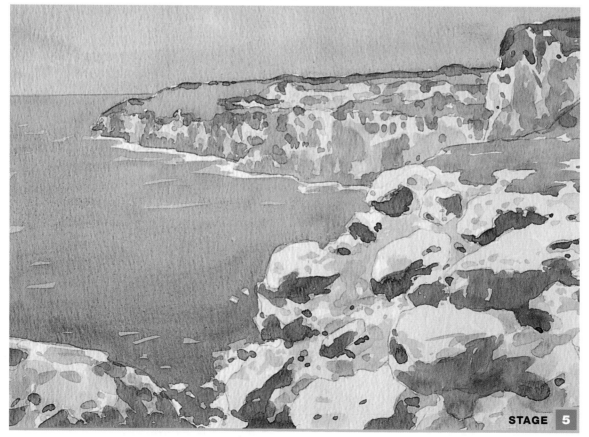

STAGE 5

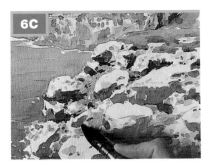

6 STRENGTHENING THE WHOLE PICTURE

Add raw sienna to the headland, darken the nearer part of the sea, paint in the lichen between the foreground rocks, add shadow to the distant cliffs and paint much stronger shadow onto the right-hand side of the foreground rocks. Finally, paint the dark rocks in the sea with a mixture of burnt sienna and phthalo blue.

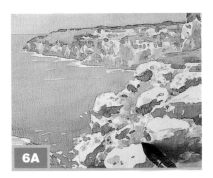

Paint in the lichen with a mixture of raw sienna and phthalo blue.

Deepen the nearer part of the sea with dilute phthalo blue and alizarin crimson.

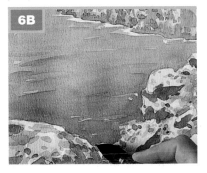

Paint shadow detail on the headland rocks with a dilute mixture of alizarin crimson and phthalo blue.

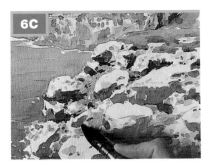

Darken the shadows on the right of the foreground rocks with a strong mix of alizarin crimson and phthalo blue.

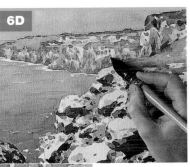

STAGE 6

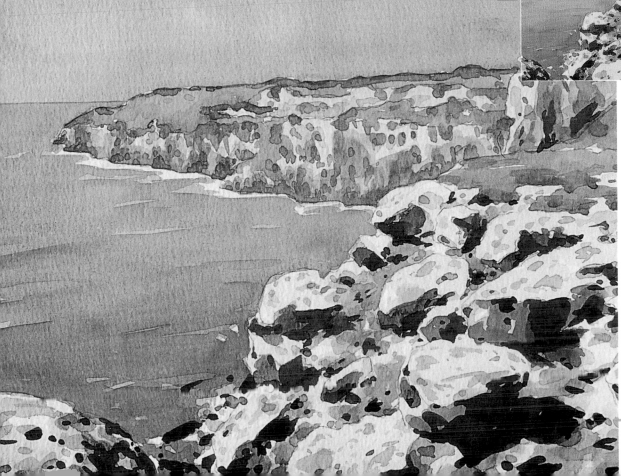

STAGE 6

By darkening the cliff on the headland and deepening the sea, the light is concentrated on the foreground rocks. This – together with the strong shadows in the foreground – creates a sunny light in the finished picture.

PAINTING FILTERED LIGHT

by PAUL TALBOT-GREAVES

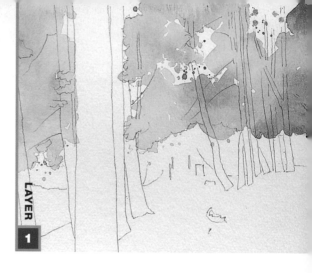

LAYER
1

The challenge here is to convey fragmented light filtering through woodland leaves as they start to change colour in autumn. The light is described through the strong contrast of the dark tree trunks against the foliage. A well-controlled spattering and stippling technique is used to suggest the filigree leaf canopy, without going into detail.

An old brush with a round, blunt tip is ideal for the spattering technique, as it can deliver large blobs of paint to the paper.

1 BLOCKING IN THE LEAF CANOPY

Start by blocking in the canopy of leaves using sap green, lemon yellow, light red and French ultramarine. Mix the paint on the paper, wet into wet, carefully leaving out the main tree trunks.

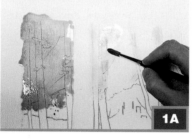

1A

Block in the leaf canopy with the size 8 brush, leaving the tree trunks unpainted.

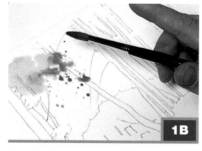

1B

Use the spattering technique in a few small areas with the blunt brush.

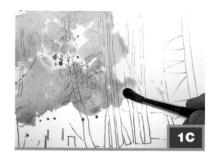

1C

Blend in more sap green with the size 8 brush.

MATERIALS

Paints

Sap green
Hooker's green
Lemon yellow
Intense violet
French ultramarine
Light red
Payne's grey

Paper

425 gsm (200 lb.)

Brushes

Size 8 sable
Old size 8 sable with blunt tip
Size 5 sable
Size 4 sable
Rigger

4B pencil

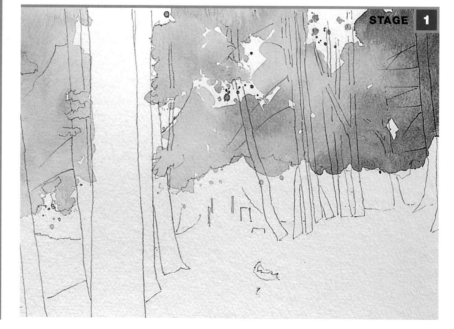

STAGE 1

STAGE 1

A varied green wash has established the foliage. Bear in mind that when you paint in the dark tree trunks later, it will make the green appear light in contrast.

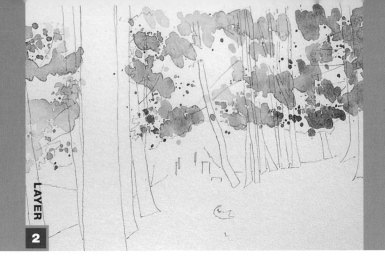

2 SUGGESTING LEAVES BY SPATTERING

Once the paint is dry, repeat the process, but this time use a stronger mix of the same colours and more spattering and stippling. Notice how the spattered and stippled areas dry with a crisp edge. Alternate between the size 8 brush and the old, blunt size 8 brush.

Spatter the paint by tapping a well-loaded brush.

2A

Stipple to blend some of the spatters.

2B

2C

Use clean water to make more spatters.

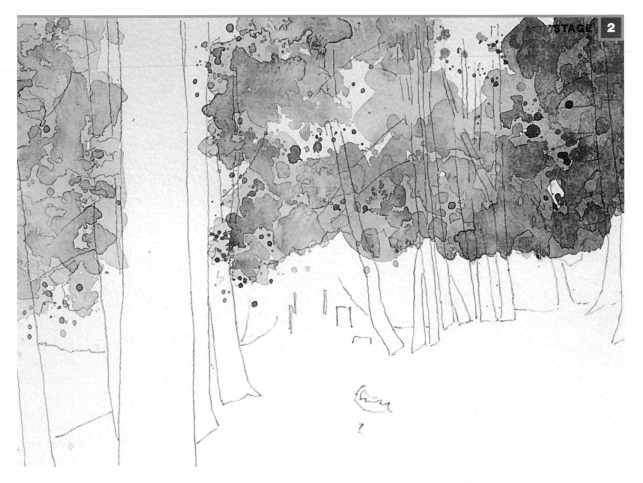

STAGE 2

STAGE 2

The controlled use of the spattering and stippling technique has created depth in the leaf canopy.

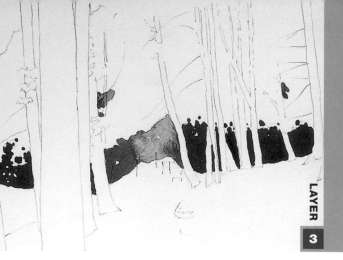

3 ADDING THE DARK BACKGROUND

Paint the background between the canopy of foliage and the woodland floor using strong Payne's grey and intense violet. Mix the paint on the paper, and use careful 'negative' painting around some of the spattered leaves to create the effect of darkness through the lower foliage (see Making Negative Shapes, page 43). Use the size 5 brush throughout.

3A

Work around the spattered leaves with a strong mix of colour.

Soften the central area with clean water.

3B

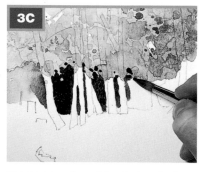

3C

Use more negative painting to describe the form of the tree trunks and leaves.

STAGE 3 The broken edge of the leaf canopy has been created. This concludes the painting of the foliage.

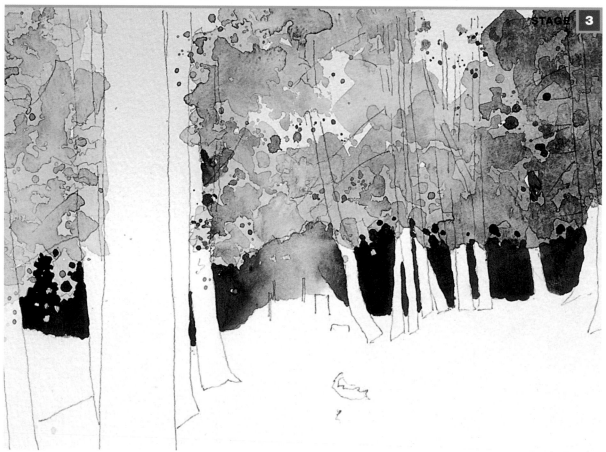

STAGE 3

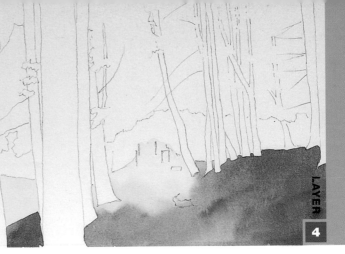

4 BLOCKING IN THE FOREGROUND

Paint the foreground woodland floor using light red and lemon yellow for the lightest areas, and light red with Payne's grey for the darker parts.

Make a pale mix of lemon yellow and light red and paint between the trees.

4A

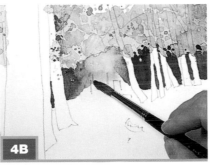

4B

Soften the pale mix already on the paper to create light in the centre of the picture.

Add more light red to darken the mix, and use it to add definition to the foreground.

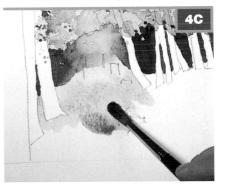

4C

STAGE 4 The foreground has been established, with light filtering through the central area, suggesting a path leading through the wood.

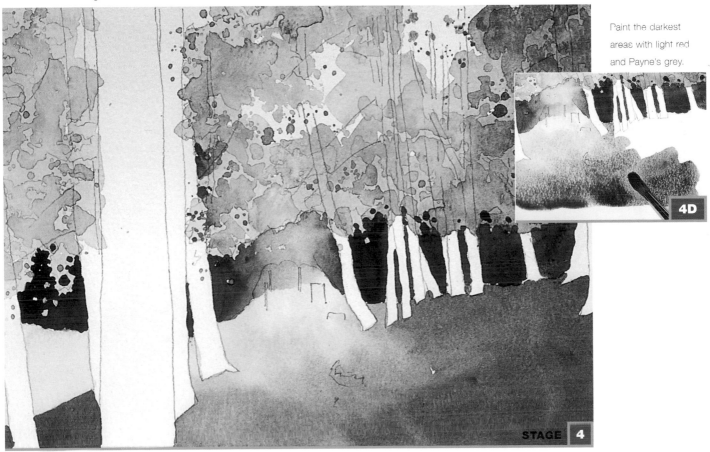

Paint the darkest areas with light red and Payne's grey.

4D

STAGE 4

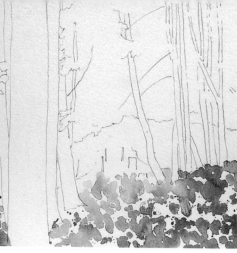

5 TEXTURING THE FOREGROUND

Texture the foreground to suggest fallen leaves. Spatter, stipple and blend the paint to create the filtered light on the woodland floor.

Spatter the light ground, masking the dark area with a piece of paper.

Soften the central pathway with light red, lemon yellow and plenty of water.

Blend the dark into the light.

STAGE 5 A flickering light has been created, with spots of dark in the foliage balanced by spots of light on the ground.

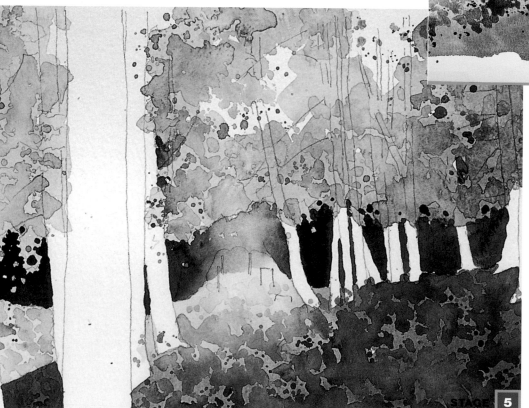

Stipple to make a random ground texture.

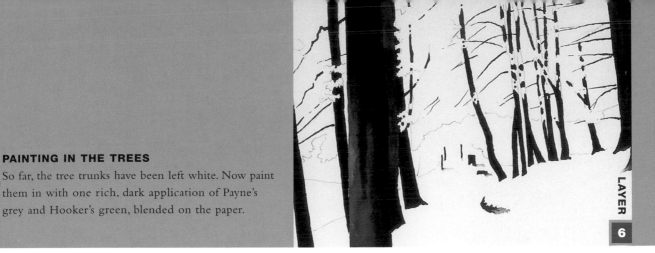

6 PAINTING IN THE TREES

So far, the tree trunks have been left white. Now paint them in with one rich, dark application of Payne's grey and Hooker's green, blended on the paper.

Blend Hooker's green into Payne's grey on the main trunk, using the size 8 brush.

6A

Paint the small trunks through the foliage, using the size 4 brush.

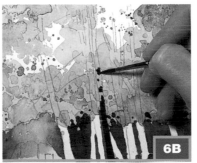

6B

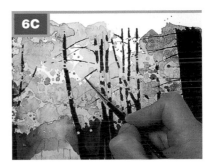

6C

Use the rigger to paint the branches with pure Payne's grey.

Use the size 4 brush and Payne's grey to paint in detail on the ground.

6D

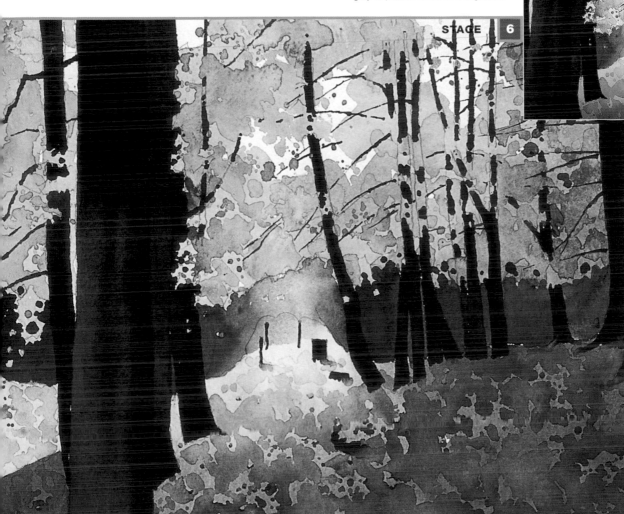

STAGE 6

STAGE 6

The finished picture. Although it is difficult to judge the tones in the leaf canopy and the background against an imagined darkness of the tree trunks, it is worth waiting until the end to paint the trunks in order to achieve pure, rich colour.

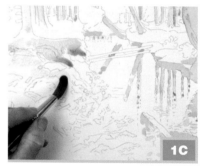

PAINTING ON LOCATION

by JANE LEYCESTER PAIGE

This painting was executed on location, on a summer's day. There is an urgency when painting outside: the light and the weather changes, and decisions have to be made quickly. Even so, time spent looking and selecting the elements that structure the picture is invaluable. Here the long, dark reflections of the distant group of sunlit trees make a focal point. Everything else is a framework for this little area of calm woodland water. A very limited palette harmonizes the colours, giving an air of serenity.

1 ESTABLISHING THE STRUCTURE OF THE PICTURE

With the size 14 brush and a thin wash of burnt sienna, block in the shape of the picture, leaving out all green or sunlit areas. (Burnt sienna is used because it is an earth colour and links the tree trunks, bare soil and peaty water.)

1A

Use a wash of burnt sienna to block in the near tree on the right, and its reflection.

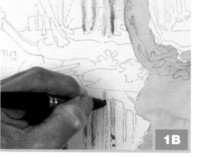

1B

Brush in the more distant tree trunks and their reflections.

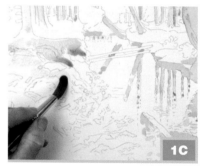

1C

Broadly wash in the trees on the left and the riverbank.

MATERIALS

Paints
 Burnt sienna
Cobalt blue
Aureolin yellow
Viridian green

Paper
Rough, 300 gsm (140 lb.)

Brushes
Size 14 sable
Size 4 sable

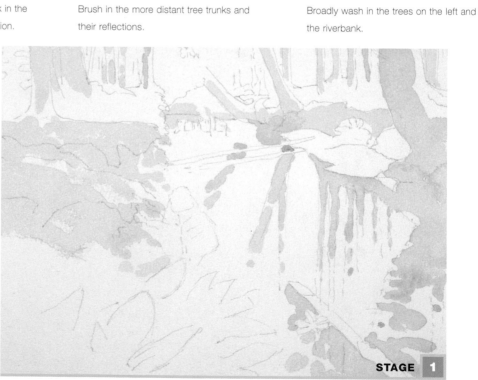

STAGE 1

The composition has been established.

STAGE 1

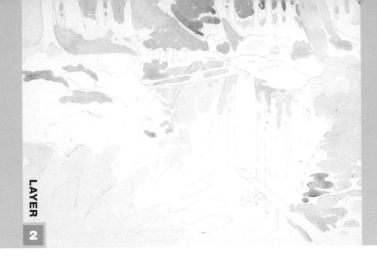

2 ESTABLISHING THE LIGHT

Mix cobalt blue with a touch of aureolin yellow, and paint in the spaces between the trees, leaving a thin strip of untouched paper on the right-hand side of the tree trunks. Paint the mixture over the three sloping trees and their reflections. Add more aureolin yellow to the mixture, and block in the area of grass and ferns in the foreground. Add even more yellow to the mixture, and paint the sunlit vegetation between the trees.

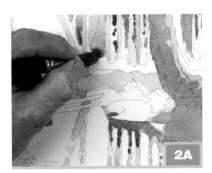

Mix cobalt blue with a touch of aureolin yellow. Take the size 14 brush, load well with paint, and use the point to pick out the spaces between the trees.

Wash the same mixture over the nearer trees and their reflections.

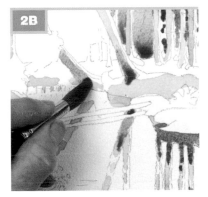

2B

2C

Add more aureolin yellow to make a pale green wash, and use it to give bulk to the foreground.

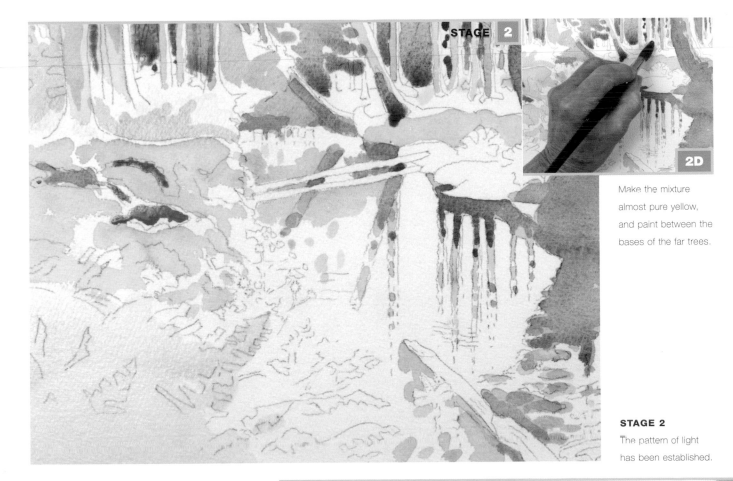

STAGE 2

2D

Make the mixture almost pure yellow, and paint between the bases of the far trees.

STAGE 2

The pattern of light has been established.

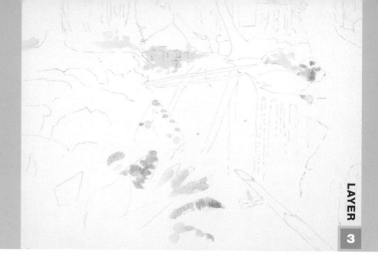

3 INTRODUCING THE BRIGHTEST PATCHES OF COLOUR

The only touches of pure colour in this painting are the yellow of the flowering plant on the near riverbank and the dragonfly. Suggest the fresh green of the reeds and ferns with a mixture of aureolin yellow and viridian green.

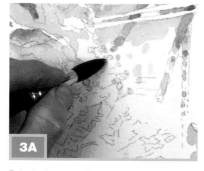

3A

Paint in the yellow flowers with pure aureolin yellow on a clean brush.

Paint in the body of the dragonfly.

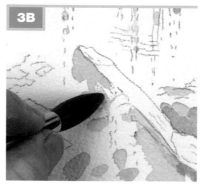

3B

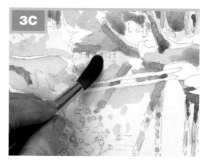

3C

Add a little viridian green to the aureolin yellow, and brush it over the reeds.

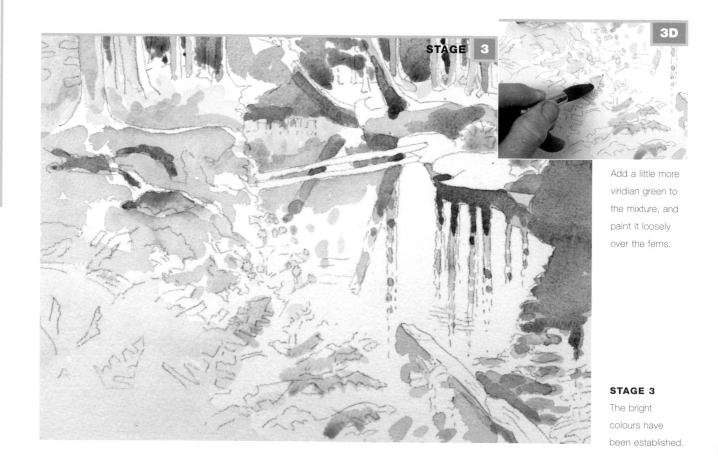

STAGE 3

3D

Add a little more viridian green to the mixture, and paint it loosely over the ferns.

STAGE 3

The bright colours have been established.

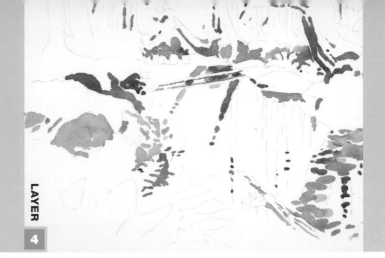

4 ADDING THE DARKS

With a mixture of cobalt blue and burnt sienna, carefully draw in the strongest dark areas with the point of the brush.

First, darken the tree on the right and its reflection.

4A

4B

Paint the reflection of the riverbank.

Use the size 4 brush to pick out the shadows along the underside and reflection of the fallen sapling.

4C

STAGE 4 The dark areas have been established, making the light areas seem brighter.

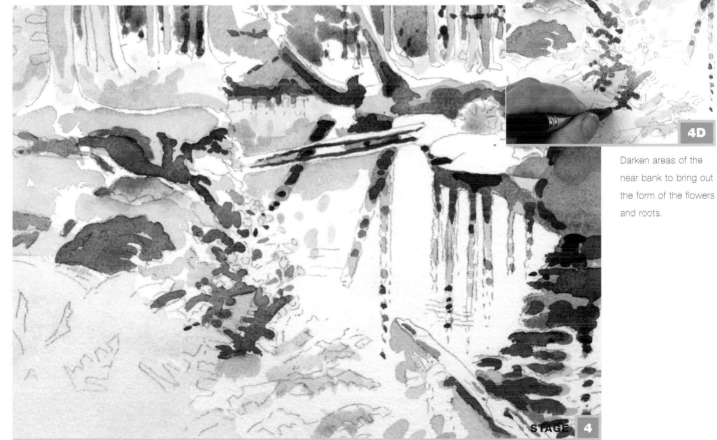

4D

Darken areas of the near bank to bring out the form of the flowers and roots.

STAGE 4

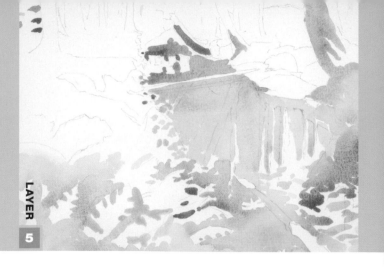

5 DEEPENING THE SHADOWS

Prepare a large quantity of a mixture of burnt sienna and viridian green (colours that are both very transparent). Paint this wash over all the water except for the reflections of the sunlit sides of the straight trees and the near ripples. Notice how this wash helps to submerge the middle part of the log lying in the water and separates the fallen sapling from its reflection. Wash the mixture over the foreground greenery, leaving shapes to suggest the form of the ferns.

Bring the burnt sienna and viridian green wash down over the water, including all but the brightest reflections.

Add more burnt sienna to the mixture, and wash this over the submerged part of the foreground log.

Add more viridian green to the mixture and darken the foreground foliage. Leave pale shapes to suggest ferns.

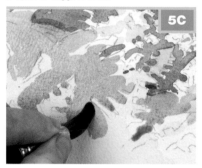

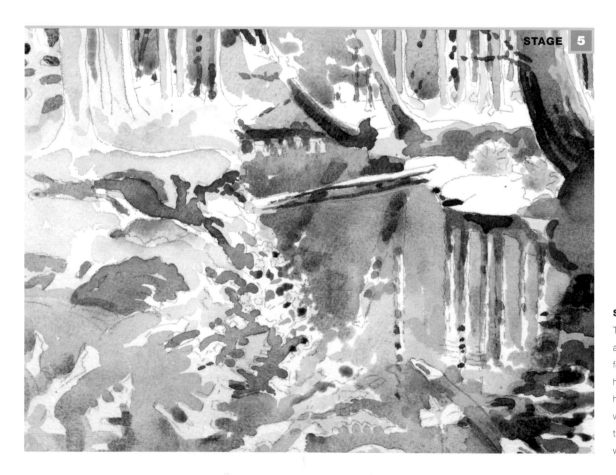

STAGE 5

STAGE 5

The water and the foreground have been harmonized with a transparent wash.

6 THE FINAL DETAILS

Add the final details using stronger mixes of burnt sienna plus cobalt blue, cobalt blue plus aureolin yellow and burnt sienna plus viridian green.

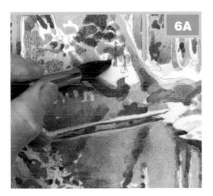

Mix cobalt blue and aureolin yellow and use it to strengthen the bushes. (Use the size 14 brush.)

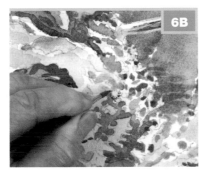

Mix burnt sienna and viridian green and use it to adjust the shadows in the water and around the flowers.

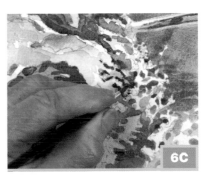

Mix burnt sienna and cobalt blue and use it to darken the area under the roots.

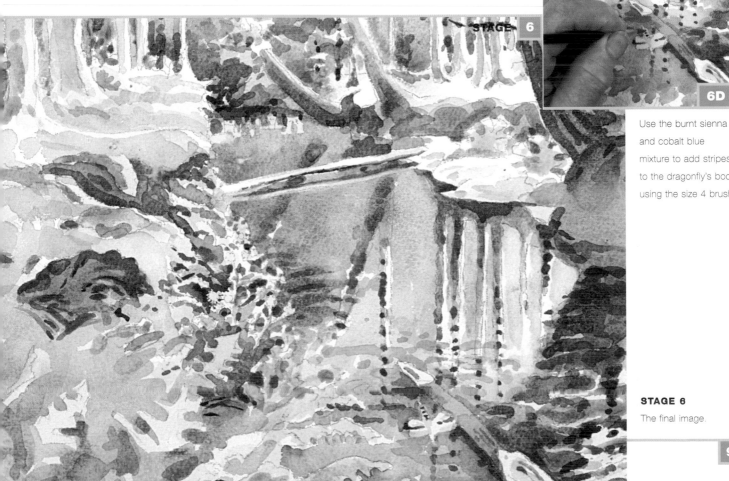

STAGE 6

Use the burnt sienna and cobalt blue mixture to add stripes to the dragonfly's body, using the size 4 brush.

STAGE 6

The final image.

EXPRESSING LIGHT

by GLYNIS BARNES-MELLISH

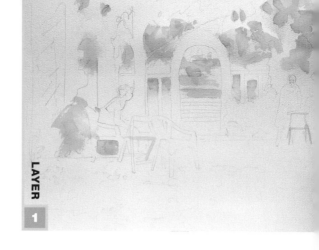

This terrace scene, on a hot afternoon in Tuscany, follows a loosely circular composition. The emphasis is on the cool light under the tree. Strong contrasts are used to convey the shaded area of the terrace (deep, neutral colours) and the foliage of the garden beyond, which basks in sunlight (bright colours). The detail in the figures, compared with the foliage around them, which is just suggested, brings the focus to the foreground and adds to the intimacy of the scene.

MATERIALS

Paints
- Cadmium yellow
- Cadmium orange
- Cerulean blue
- French ultramarine
- Violet
- Sap green
- Emerald green
- Hooker's green
- Burnt sienna
- Alizarin crimson
- Burnt umber
- Brilliant pink

Paper
Cold-pressed, 300 gsm (140 lb.)

Brushes
Size 14 sable
Size 6 sable
Size 5 sable

1 PAINTING THE SUNNY BACKGROUND

First of all, establish the sunlit background area, against which the dark shade of the terrace can be built up. Use cadmium yellow and the size 14 brush.

1A

Apply a wash of cadmium yellow to the parts of the garden in sunlight.

1B

Paint in the sunlit chair.

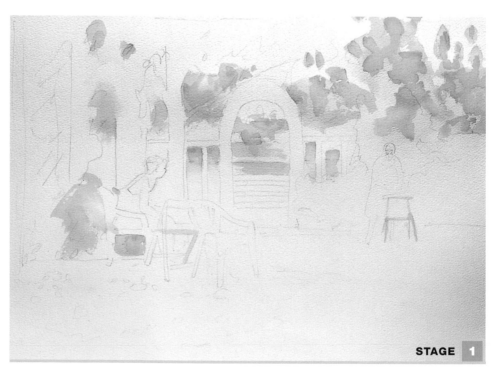

STAGE 1

STAGE 1

The sunny yellow has set the scene, painted in loosely and swiftly with a large, round brush.

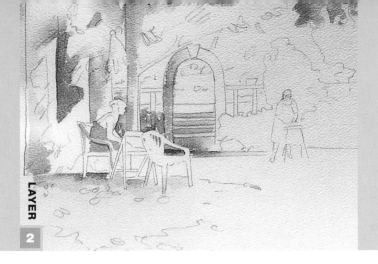

2 ADDING BLUES

Use cool, cerulean blue for the sky and into part of the foliage. Use a warmer blue, French ultramarine, for the darker foliage, the arch and steps, the shadow around the chair and around the figure. Use the size 14 brush for the sky and the foliage and the size 6 brush for the more detailed work around the chair and figure.

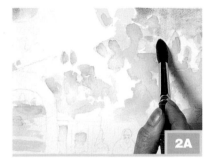

2A

Paint in the sky with cerulean blue.

Use French ultramarine around the central chair.

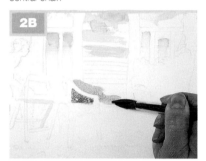

2B

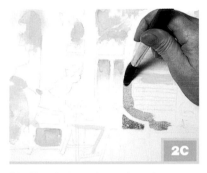

2C

Take French ultramarine up the arch.

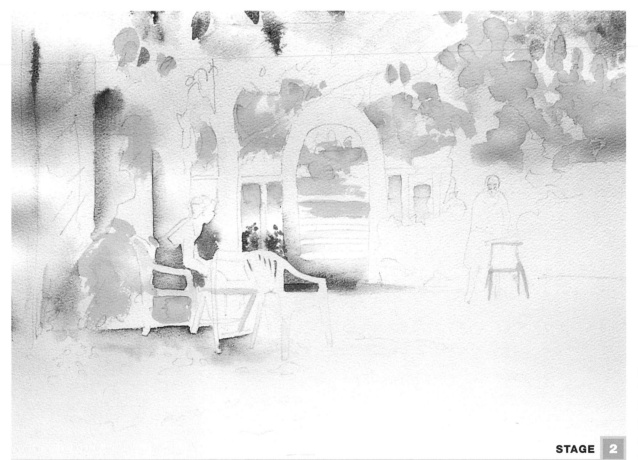

STAGE 2

The composition begins to take form with the addition of the blues.

STAGE 2

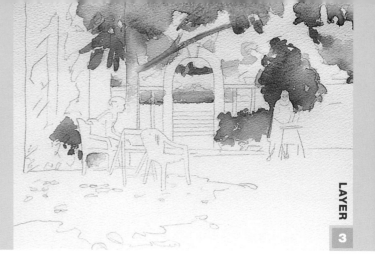

3 CREATING THE FOLIAGE

Use sap green, emerald green and Hooker's green to build up different tones and colours in the foliage. Use the size 14 brush for this layer.

Add touches of emerald green to the background foliage.

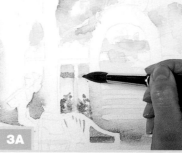

Apply sap green, leaving some edges crisp and blending others.

Paint the garden glimpsed through the gateway with sap green.

STAGE 3 A great deal of work has been done with this layer, building up the shady intimacy of the terrace. Notice the shimmering effect achieved by adding touches of bright green here and there.

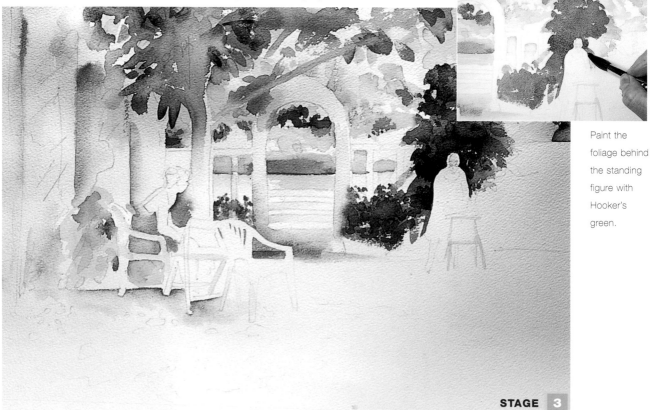

Paint the foliage behind the standing figure with Hooker's green.

STAGE 3

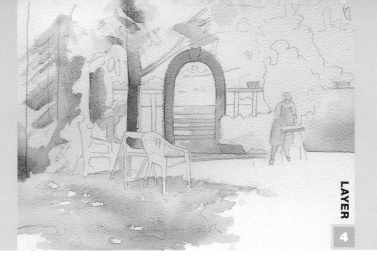

4 USING NEUTRALIZING COLOURS

Use burnt sienna, alizarin crimson and violet in this layer, applying them separately in some places, and as a mixture in others. This allows for variation between warm and cool shadows.

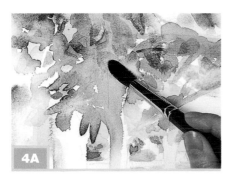

4A

Make a watery solution of burnt sienna and alizarin crimson and use it to neutralize areas of green in the foliage, establishing shadows.

Cool the mixture with a touch of violet, and use it for the flesh colour of the figures.

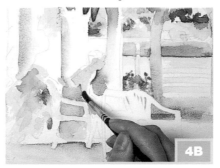

4B

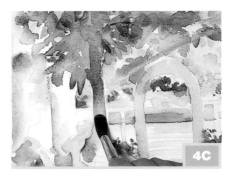

4C

Paint pure burnt sienna onto the tree trunks.

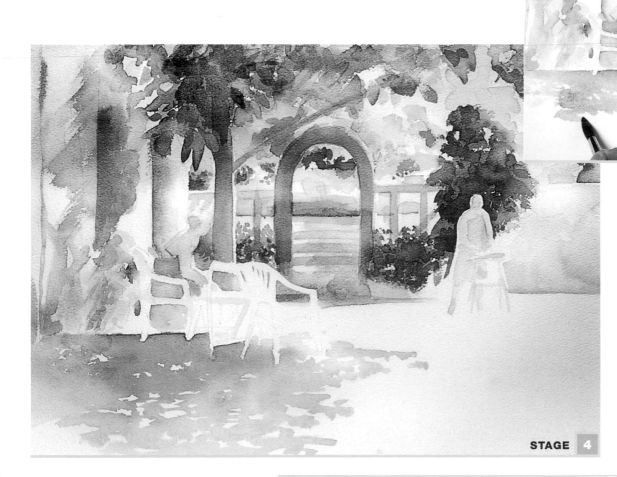

4D

Create the dappled shade with a mixture of burnt sienna and violet.

STAGE 4

STAGE 4

By using clever mixtures of the same three transparent colours, the shady green of the foliage has been neutralized, the flesh colour introduced and the dappled shade painted in.

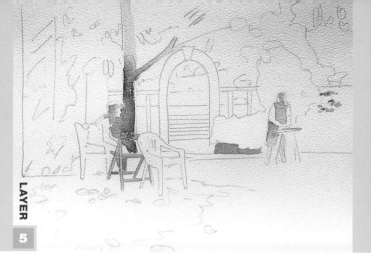

5 ADDING BRIGHT COLOURS

Use the size 6 brush to add touches of bright colours – cadmium orange, alizarin crimson, burnt sienna, pink and violet – to pick out details and give sparkle to the painting.

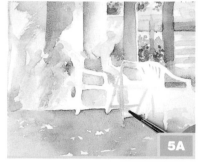

Apply cadmium orange to the chair next to the seated figure.

Add burnt sienna and violet around the seated figure.

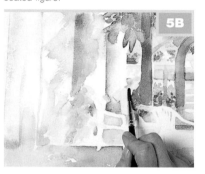

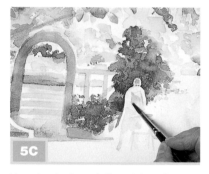

Use a touch of pure brilliant pink on the dress of the standing figure.

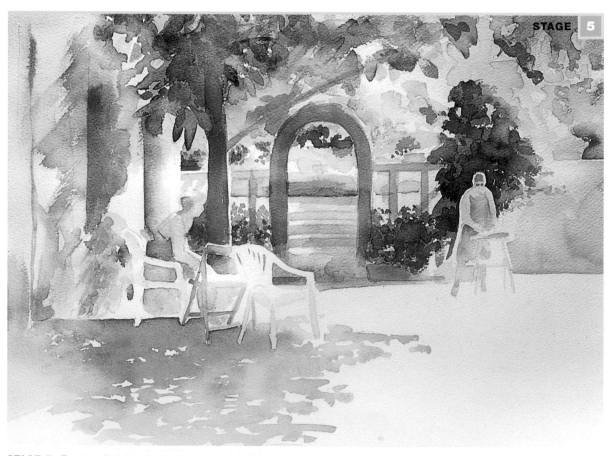

STAGE 5 Touches of bright colour have suggested the brickwork of the wall, given form to the tree trunk and the chair and brought the figures alive. A bright patch of burnt sienna and alizarin crimson has been applied in the centre of the painting, to depict a terracotta planter.

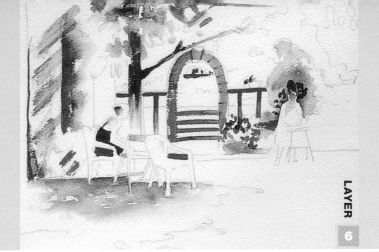

6 ADDING DARK DETAILS

Use a mixture of French ultramarine and burnt umber for the darks in this layer, to sharpen up the composition and deepen the contrasts. A touch more colour is added to the plants.

With the size 5 brush, add detail around and to the seated figure.

Paint shadows on the wall and darken the branches and foliage.

Add deeper shadow to the terrace, to increase the dappled effect.

STAGE 6 The finished picture. The stonework on the arch has been suggested using the point of the size 14 brush. The sense of shade has been created by the dark masses in the tree and on the terrace. Details added to the figures and archway bring them into focus.

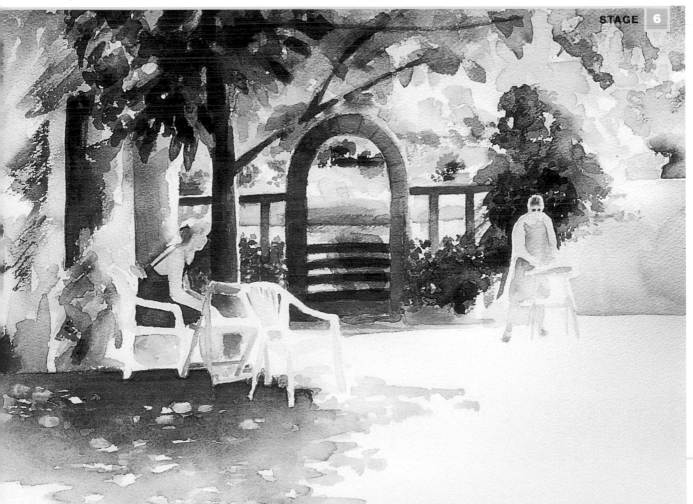

STAGE 6

CREATING A SENSE OF SPACE

by GLYNIS BARNES-MELLISH

LAYER 1

Venice is a constant source of inspiration for artists. While some choose intimate, narrow canal scenes with bridges and gondolas, here is a wider view gazing across a broad expanse of water to distant domes and towers that reach up into the sky. In order to keep a sense of space, a deliberate decision was made not to paint in the sky and only to add a small amount of paint to the water. Cool colours – cerulean blue and raw sienna – are used for the lofty domes, and warmer colours – French ultramarine and burnt sienna – for the bulk of the buildings and the foreground. This helps to achieve the huge spatial distances in the painting. Pure bright colours here and there, as on the striped parking poles, add vitality to the picture.

1 PLOTTING THE BUILDINGS

With a wash of pure raw sienna, plot the whole mass of buildings and the foreground structures.

Underpaint the stripes on the parking poles with the flat brush.

1B

1A

Use the size 14 brush to establish the shape of the dome.

STAGE 1 The composition has been set: there is a loose, circular movement from the domes through the poles, to the foreground fence, and back across the water to the nearest buildings.

MATERIALS

Paints

Raw sienna

Violet

French ultramarine

Cerulean blue

Cadmium orange

Alizarin crimson

Mix of burnt umber, Prussian blue and alizarin crimson

Mix of French ultramarine and burnt sienna

Viridian green

Cadmium red

Paper

Cold-pressed, 300 gsm (140 lb.)

Brushes

Size 14 sable

Size 6 sable

4.5 mm (³⁄₁₆ in.) flat

Sharp 2B pencil

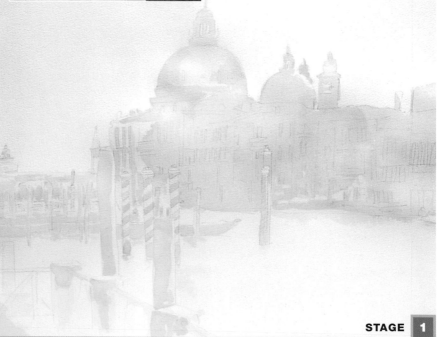

STAGE 1

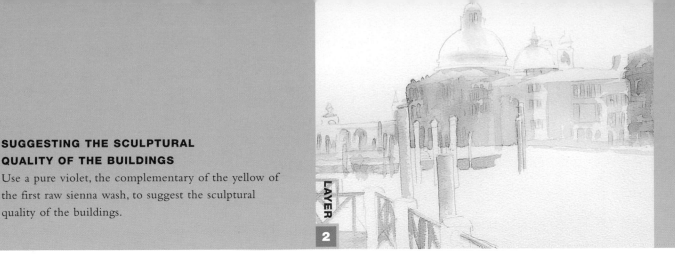

2 SUGGESTING THE SCULPTURAL QUALITY OF THE BUILDINGS

Use a pure violet, the complementary of the yellow of the first raw sienna wash, to suggest the sculptural quality of the buildings.

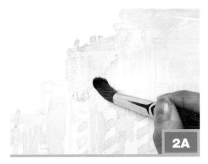

2A

Using the size 14 brush, apply a wash of violet to darken the silhouette of the buildings against the sky.

Deepen the tones behind the poles to make them stand out.

2B

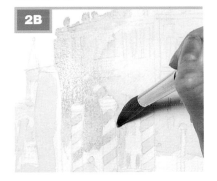

2C

While the paint of the first wash is still damp, use the size 6 brush and quick, sure strokes to suggest the windows.

Use a dry brush to hint at the criss-cross structure of the near fence.

STAGE 2

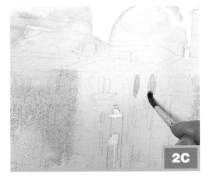

2D

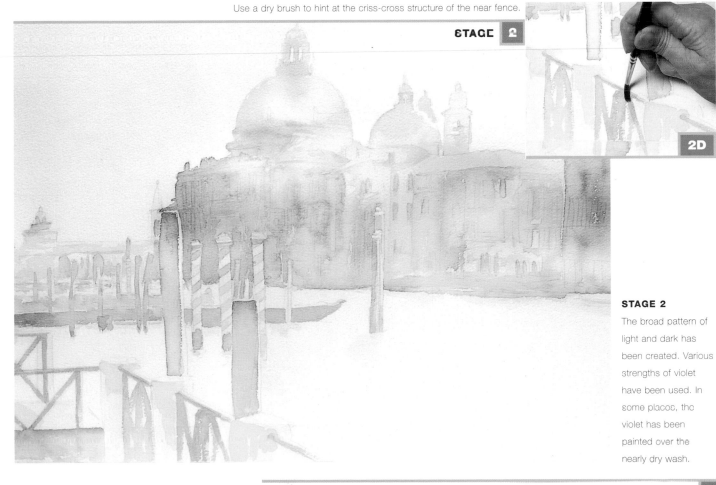

STAGE 2

The broad pattern of light and dark has been created. Various strengths of violet have been used. In some places, the violet has been painted over the nearly dry wash.

3 ADDING COOL AND WARM COLOURS

Use cool cerulean blue on the domes and more distant structures and a warmer blue, French ultramarine, on the nearer structures. This will begin to suggest the relative distances of different buildings. Paint cadmium orange on the roofs, and use a warmer mixture – a thin wash of alizarin crimson and cadmium red – on the buildings.

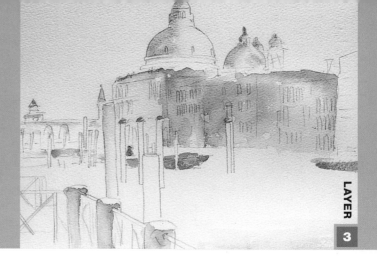

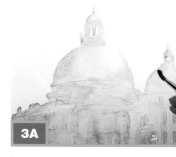

3A Take the size 6 brush and wash cerulean blue over the side of the domes.

Paint the foreground posts with a thin mix of cadmium orange and alizarin crimson.

3B

3C Add touches of French ultramarine to the red-toned buildings to suggest shadows.

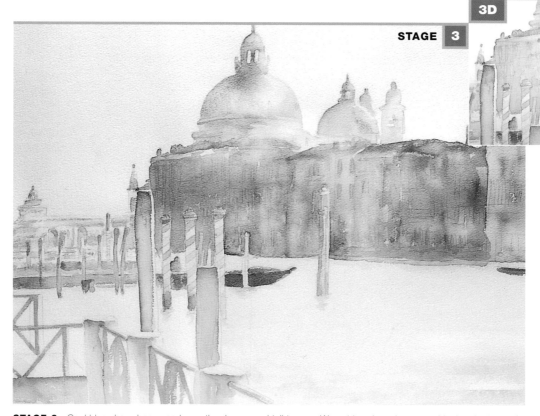

STAGE 3

3D Change to the size 14 brush and wash a thin solution of alizarin crimson and cadmium red over the buildings.

STAGE 3 Cool blues have been used over the domes and tall towers. Warm blues have been used in the shadows of the buildings. Pale, cool reds have put the roofs into the distance, while the bulk of the buildings has been brought closer with a wash in a warmer red.

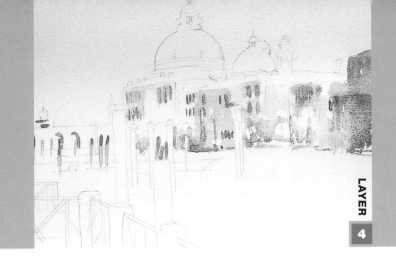

4 DEEPENING THE DARKS

In this layer, deepen the darks with a mixture of burnt sienna and French ultramarine. To make warm darks, use more burnt sienna in the mixture; to make cooler darks, use more blue in the mixture.

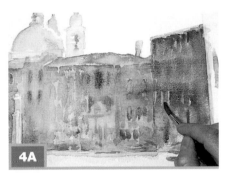

Leave light patches in the wash to suggest structure without going into detail.

Bring the striped poles forwards by applying a dark wash around them.

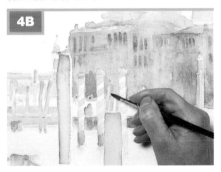

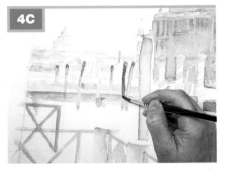

Darken the distant poles.

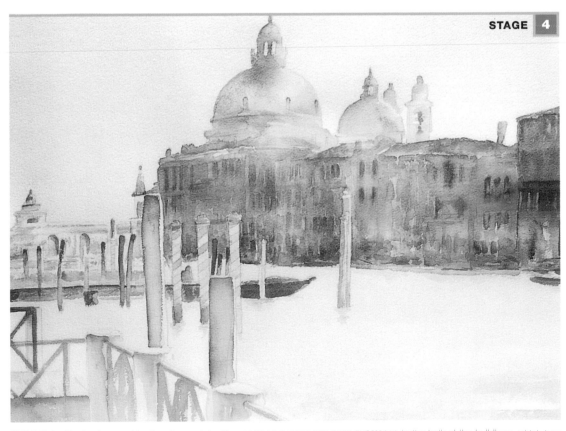

STAGE 4 The background is almost complete. The addition of darks has given substance to the bulk of the buildings, which has made the domes and turrets recede.

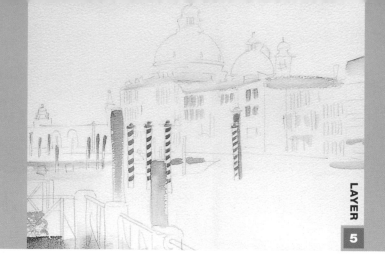

5 ADDING BRIGHT COLOURS

Liven up the painting with bright reds, greens and blues.

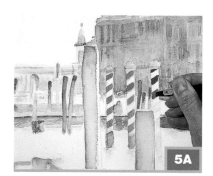

With the flat brush, paint the stripes on the parking poles with cadmium red.

5A

Apply burnt sienna to the near posts.

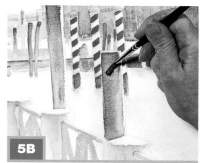

5B

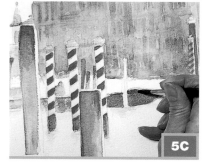

Paint the boat with viridian green.

5C

STAGE 5 Touches of pure bright cadmium red, burnt sienna and viridian green have brought the painting to life and given focus to the foreground. A thin wash of pure French ultramarine has suggested the near water and helped the circular movement of the composition.

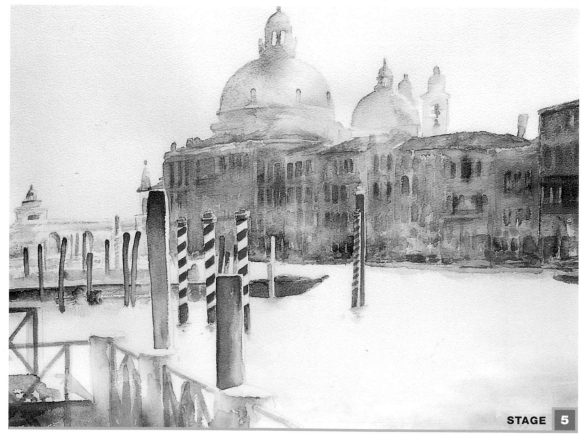

STAGE 5

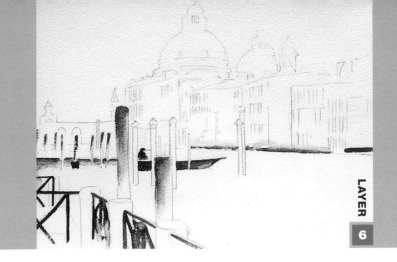

6 ADDING THE FINAL DARKS

Make a mixture of burnt umber, Prussian blue and alizarin crimson to create a colour that is nearly black. Use this mix to add the final darks.

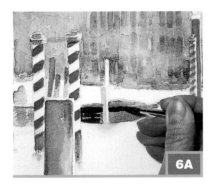

Add detail to the boat. This helps to emphasize the post.

Stroke detail on the foreground fence to give it solidity.

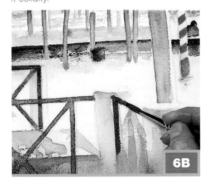

6B

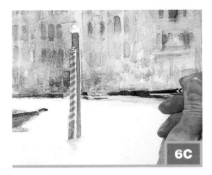

6C

Add darks to the far buildings, helping to emphasize the water's edge.

STAGE 6

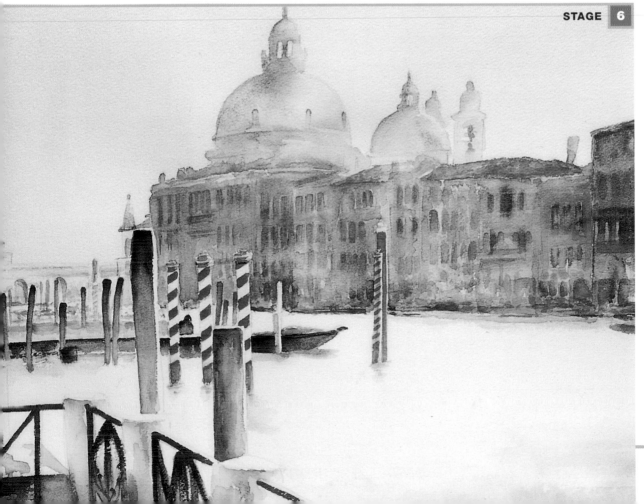

STAGE 6

The foreground posts have also been darkened, adding to the three-dimensional aspect of the painting. The final picture has a great sense of height and distance, achieved by leaving large expanses of sky and water unpainted, and cleverly using cool and warm colours.

WET INTO WET

by JANE LEYCESTER PAIGE

LAYER 1

An old, sunken doorway in a walled courtyard garden provides a dark background that sets off a pot of striking blue agapanthus flowers. It is surrounded by a pleasing jumble of brambles, foxgloves and discarded stones. To keep the flowers in focus, detail will be required, whereas the untidy bulk of the brambles can be expressed by painting wet into wet. The play of light against dark and dark against light suggests bright sunlight.

1 ESTABLISHING THE SHAPE OF THE COMPOSITION

With the size 16 brush and a rich wash of raw sienna, paint the doorway and the stonework, including the crack of light above the door. Paint the wash around the bold shapes of the agapanthus. Use a hint of raw sienna in the foliage to the left and right of the picture.

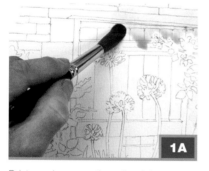

1A

Paint raw sienna over the wall and doorway area.

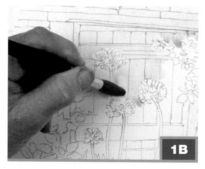

1B

Paint around the shape of the flower-heads.

1C

Paint a light wash over the right-hand side of the foliage.

MATERIALS

Paints
- Raw sienna
- Cobalt blue
- Aureolin yellow
- Permanent rose
- Viridian green

Paper
- 300 gsm (140 lb.)

Brushes
- Size 16 synthetic
- Size 10 synthetic
- Size 4 sable

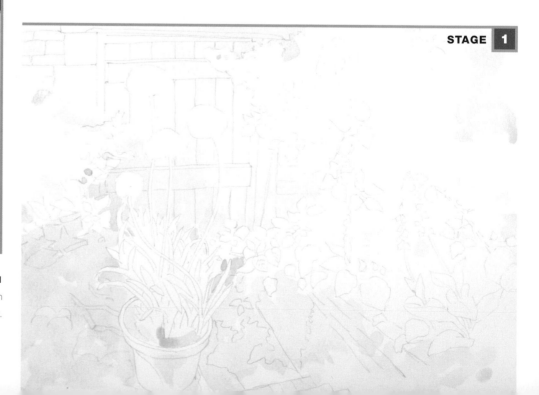

STAGE 1

STAGE 1

The structure of the picture has been established with this first wash.

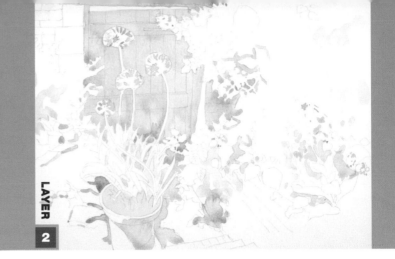

2 DEFINING THE TONAL PATTERN

Cobalt blue is ideal for the agapanthus flowers, and it will also be used throughout the painting. Use it for underpainting the shadows, and over the raw sienna to make the faded green of the paintwork on the door.

2A

Use the cobalt blue to block in the door and lintel, leaving out the gap over the door.

Block in the agapanthus buds.

2B

2C

Paint in the shadows.

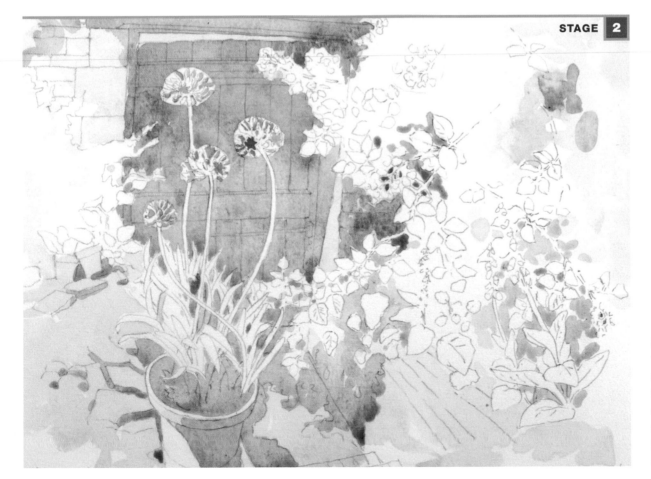

STAGE 2

STAGE 2

The tonal pattern of the painting has been laid down, making a basis on which the picture can develop.

3 BLOCKING IN THE FOLIAGE, WET INTO WET

Block in the foliage with a broad wash of aureolin yellow, leaving spaces for the large heads of the bramble flowers. While the yellow paint is still wet, add cobalt blue on the shaded side of the foliage. This builds up the bulk of the foliage.

Apply an aureolin yellow wash, avoiding the bramble flowers.

Quickly add the cobalt blue, wet into wet.

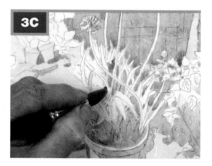

Paint the agapanthus leaves with aureolin yellow, leaving a firm, dry edge around the highlights.

STAGE 3 The bulk of the foliage has been created.

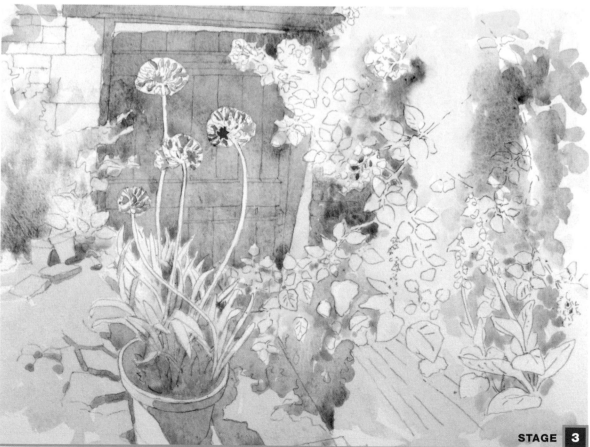

STAGE 3

4 ADDING WARMTH TO THE PICTURE

Use pure permanent rose for the foxglove flowers and to suggest the bramble stalks. Then, with a mix of raw sienna and permanent rose, paint the terracotta pots and add a touch of warmth to the stone walls. Add permanent rose to cobalt blue to make a warm shadow colour for picking out detail in the door. The use of the same red for the flowers, pots and shadows gives harmony to the developing picture.

Use pure permanent rose for the foxgloves.

4A

4B

Mix permanent rose and raw sienna and paint the pots.

Mix permanent rose and cobalt blue for the door details.

4C

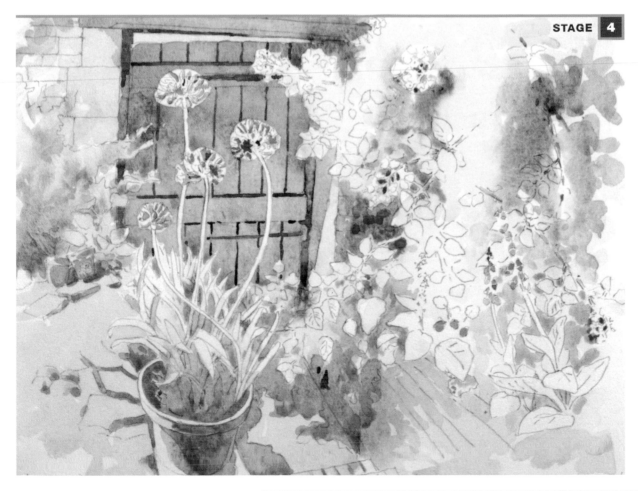

STAGE 4

STAGE 4

Warmth has been added to the picture.

5 ADDING THE DEEP SHADOWS

The painting must be completely dry before this layer is added. Mix permanent rose with viridian green to make a deep grey wash. (It is important to add the permanent rose to the viridian green a very little at a time, as the strength of permanent rose can soon drown viridian green.) Wash this mixture over the door and its cast shadow, being careful to leave out the slit of light between the door and the lintel. Pick out the detail around the agapanthus flowers, and suggest the bulk of the foliage.

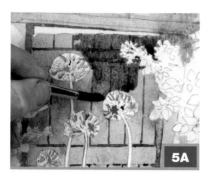

With the size 10 brush, wash the grey across the door.

Paint the shadows of the bramble on the sunken wall.

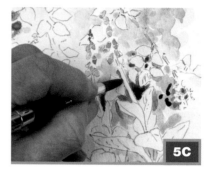

Increase the shadow behind the foxglove. Suggest the bulk of the foliage.

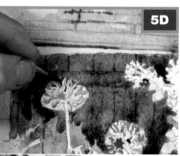

With the size 4 brush, pick out the detail around the agapanthus flowers.

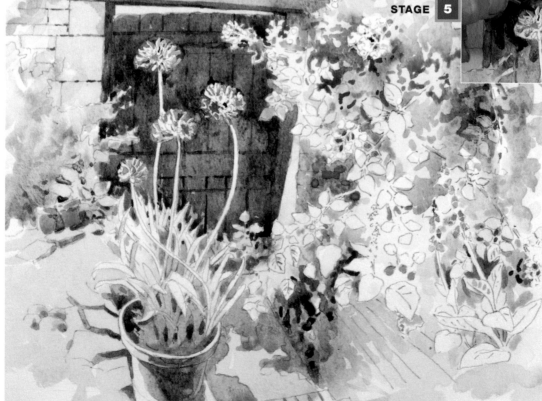

STAGE 5

STAGE 5
The strong shadows indicate that the scene is bathed in midday sun.

6 THE FINAL DETAILS

This stage is more about thinking than doing. Apply some touches of pure colour: a little permanent rose on the foxgloves, a little more cobalt blue on the agapanthus buds and green on the flower stalks. Deepen the shadows behind the bramble flowers to give them a lacy quality, and refine the agapanthus leaves to strengthen the foreground. Use the size 4 brush for the stalks and size 10 for the other details.

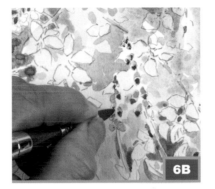

Model the flower stalks with viridian green and permanent rose.

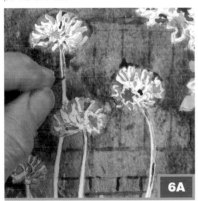

6A

6B

Add more colour to the foxglove with permanent rose.

Refine the agapanthus leaves with the mixture of viridian green and permanent rose.

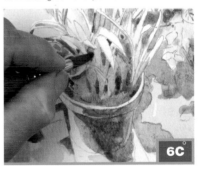

6C

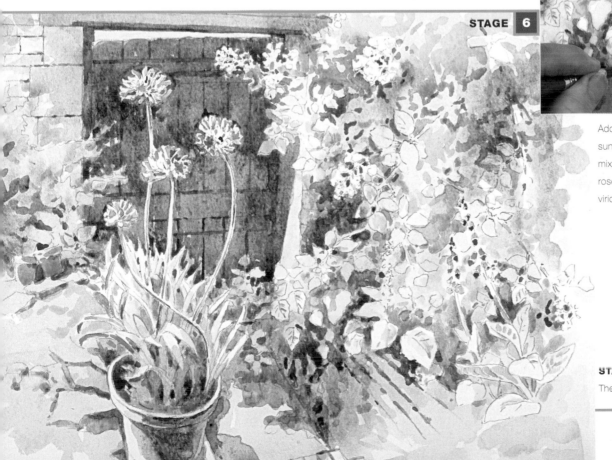

6D

STAGE 6

Add detail to the sunken wall with a mixture of permanent rose, raw sienna and viridian green.

STAGE 6
The finished painting.

CAPTURING BONE STRUCTURE

by JOHN PAIGE

This is a triangular composition of a young woman with a gentle expression and the hint of a smile playing around her lips. The cool lighting from the left beautifully emphasizes her bone structure, and her rust-coloured top lends warmth to the portrait without dominating it. Use a low-key colour scheme to link the hair, skin and top. This subdued palette allows the lighting to give full value to the bone structure.

1 ESTABLISHING THE LIGHT AREAS

Paint a wash of raw sienna over everything (including the whites of the eyes), except for the lightest areas of the hand and head. Use the size 14 brush.

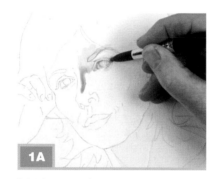

1A

Paint the eye sockets.

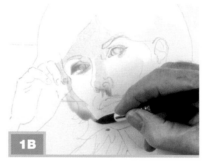

1B

Define the far cheek by painting the hair beyond it.

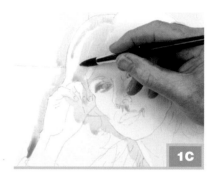

1C

Create the areas of highlights on the hair and hand.

MATERIALS

Paints

Raw sienna

Burnt sienna

Cobalt blue

French ultramarine

Permanent rose

Paper

300 gsm (140 lb.)

Brushes

Size 14 synthetic

Size 10 synthetic

2B pencil

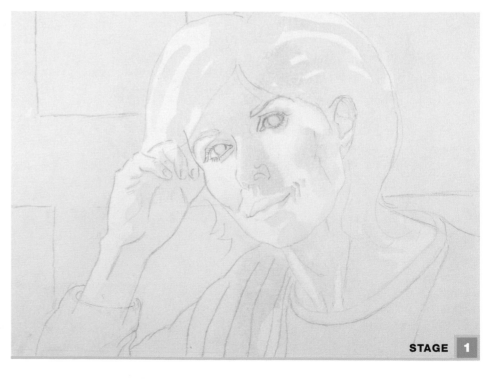

STAGE 1

The lightest areas have been established.

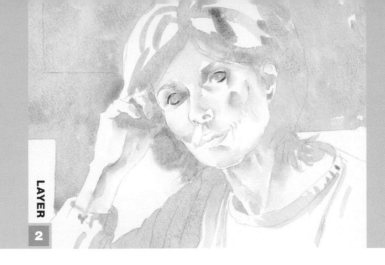

2 CREATING THE TONAL PATTERN

Use pure cobalt blue, washed over the raw sienna, to make a soft green for the shadows on the face and in the hair. Treat the mouth in the same way as the rest of the face.

Apply a wash of cobalt blue to blend the hair into the forehead.

Add shadows to the hair to show up the jawbone.

2B

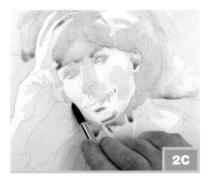

2C

Darken the hair to create the far cheekbone.

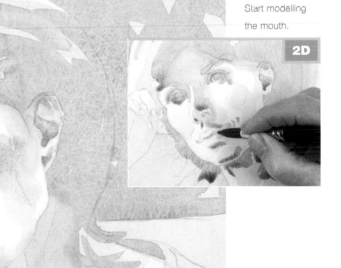

Start modelling the mouth.

2D

STAGE 2

The modelling of the bone structure and the tonal pattern of the painting have been created.

STAGE 2

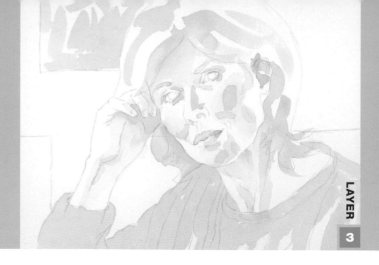

3 ADDING WARMTH TO THE PAINTING

For this stage, use permanent rose to give warmth to the complexion, increase the darkness of the hair, and establish the rust colour of the top. Do not add any colour to the eyeball.

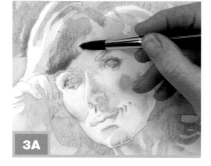

3A

Take a thin wash of permanent rose over the hair and forehead.

Add colour to the features.

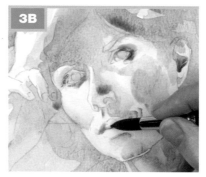

3B

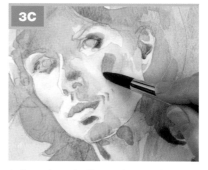

3C

As the pale wash dries on the near cheek, add some darker permanent rose.

STAGE 3 The portrait has begun to approach the desired colours and tonal values.

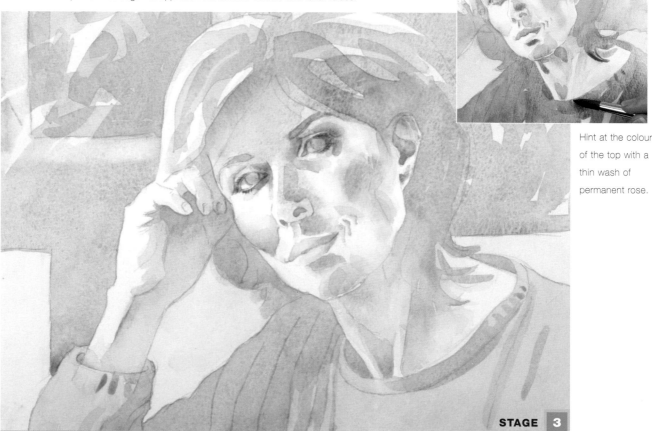

STAGE 3

3D

Hint at the colour of the top with a thin wash of permanent rose.

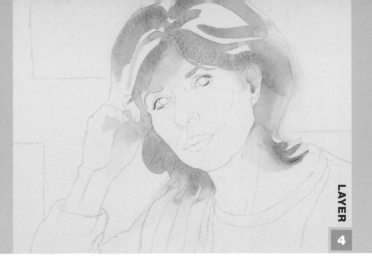
4 ENRICHING THE DARKS

Use a mixture of burnt sienna and French ultramarine to emphasize the darkness of the hair and some of the shadows.

Use the burnt sienna and French ultramarine wash to blend the hair into the forehead.

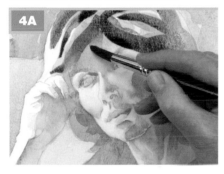

Darken and soften the hair at the back of the head.

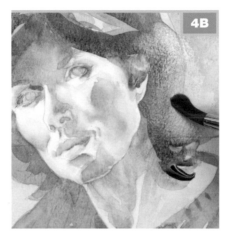

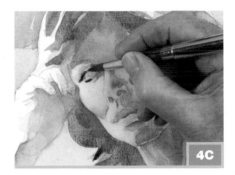

Darken the eyelashes with the size 10 brush.

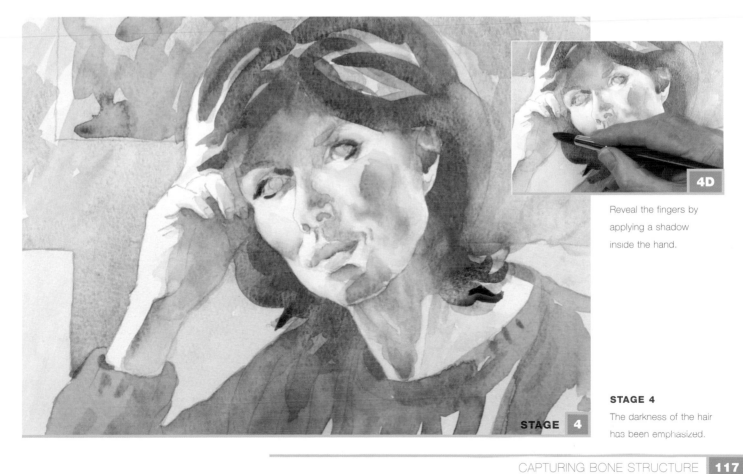

Reveal the fingers by applying a shadow inside the hand.

STAGE 4

The darkness of the hair has been emphasized.

5 HEIGHTENING THE WARMTH OF THE PAINTING

Apply a thin wash of burnt sienna to add warmth to the hair and top. (With paint added to the hair at each stage, it is always kept a tone darker than the rest of the painting.)

LAYER 5

Apply a wash of burnt sienna to blend the hair into the forehead.

Enrich the colour of the top.

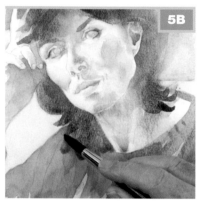

5B

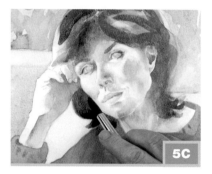

Darken the hair behind the far cheek.

5C

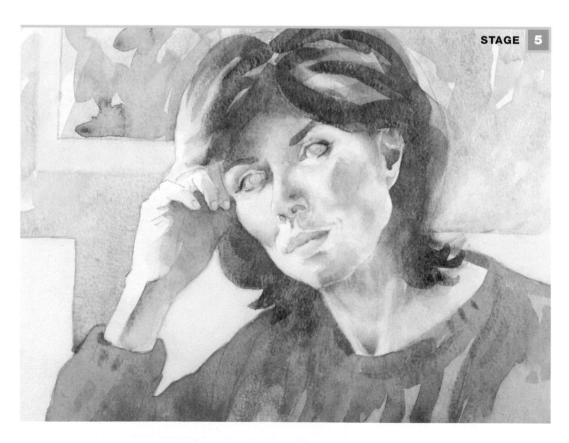

STAGE 5

STAGE 5

The portrait is nearly finished. The colour and tone have been checked throughout. Areas where colour is too strong or where edges are too harsh have been softened; more colour has been added to weak spots.

6 THE FINAL DETAILS

Darken the hair and the near eyebrow and eyelashes with a mixture of burnt sienna and French ultramarine, and use permanent rose to add a little more colour to the centre and near corner of the mouth. Add cobalt blue to the top edge of each iris; soften the lower edge.

Darken the hair with a mixture of burnt sienna and French ultramarine. Note the soft and hard edges.

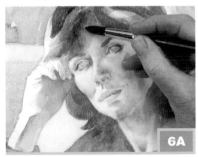

6A

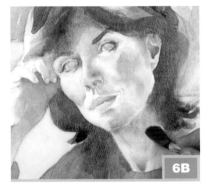

6B

Put a soft, dark wash under the chin and on the neck.

Add a touch of cobalt blue to the top of each iris, softening the bottom edge.

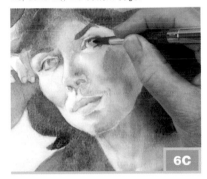

6C

STAGE 6

Add a touch of permanent rose to the centre and near corner of the mouth.

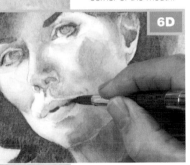

6D

STAGE 6

The portrait is complete. The pupils were added to the eyes with dark paint (when the blue of the iris had dried), and the eyelashes were picked out with a sharp pencil.

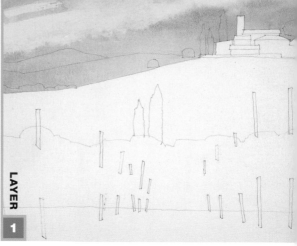

MAKING USE OF PERSPECTIVE

by IAN SIDAWAY

In this painting of a vineyard in Tuscany, the composition depends on strong perspective: linear, in the diminishing lines of the rows of vines; and aerial, in the gradual increase of cool blue in the distance until the furthest hills fade into the sky. The tones also become closer together the further away you look. Thus the tonal difference between the buildings and the sky is minimal compared to the tonal difference between the vine trunks and their leaves.

PAINTING THE SKY

Using the sponge, apply puddles of clean water to areas of the sky. Paint a blue wash up to the puddles and suggest soft, white clouds by merging the edges of the puddles into the blue. (Mix cerulean blue with a little ultramarine blue for the sky colour, and carry this wash over the distant hills.)

MATERIALS

Paints

Cerulean blue

Ultramarine blue

Payne's grey

Raw umber

Yellow ochre

Cadmium yellow (medium)

Cadmium red (medium)

Cadmium orange

Sap green

Dioxazine purple

Burnt sienna

Paper

Cold pressed, 300 gsm (140 lb.)

Brushes

Sizes 7 and 10 round

Medium-sized rigger

6 mm (¼ in.) flat brush

Natural sponge

HB pencil

Wax candle

Apply little puddles of clean water with the sponge.

Mix a wash of cerulean blue and ultramarine blue for the sky. Use the size 10 brush, suggesting clouds as you paint.

Drag the brush to produce a broken edge.

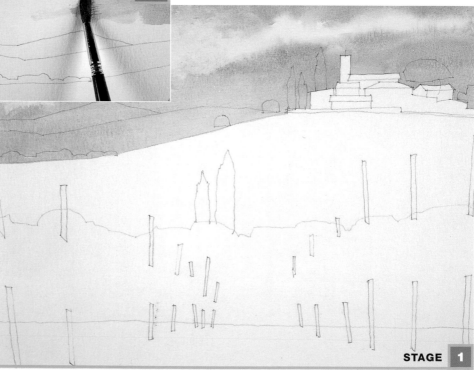

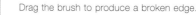

STAGE 1

The sky and distant hills have been painted and the wash has been taken carefully around the buildings.

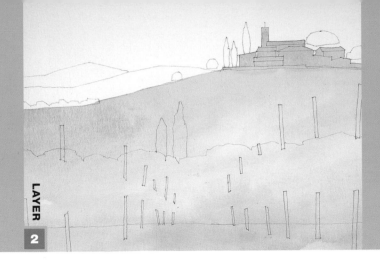

2 BLOCKING IN THE LAND MASS

Paint the buildings with wet–into–wet washes of yellow ochre and dioxazine purple. Apply wet–into–wet washes of yellow ochre, sap green and raw umber over the hill slope and vines. Paint a light wash of raw umber over the foreground.

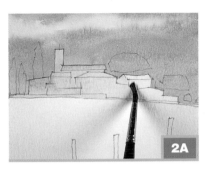

2A

Paint the buildings with a wash of yellow ochre and dioxazine purple, using the size 7 brush.

Use the size 10 brush to take a green wash (made from sap green, yellow ochre and raw umber) over the hill slope and vines.

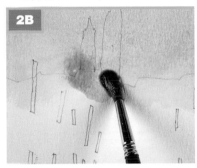

2B

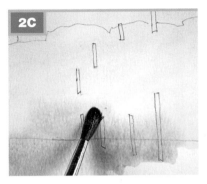

2C

Bring a wash of raw umber down over the foreground.

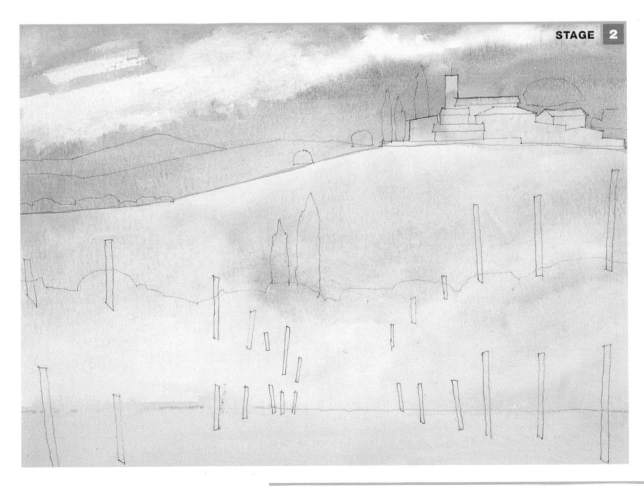

STAGE 2

STAGE 2

The land and the sky have been painted and the broad shape of the composition established. The cool blue denotes distance and the warm umber brings the foreground nearer.

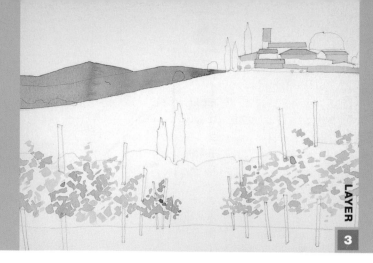

3 DEVELOPING THE SCENE

Paint the distant hills with a mix of ultramarine blue and dioxazine purple. Model the buildings with washes of yellow ochre, raw umber and burnt sienna. Paint the leaves of the vines using sap green, cadmium yellow and a touch of cadmium red.

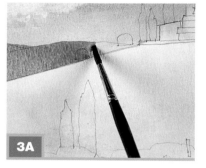

Paint in the hills with a wash of ultramarine blue and dioxazine purple.

Model the buildings with yellow ochre, burnt sienna and raw umber, using the rigger.

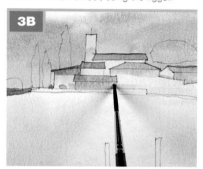

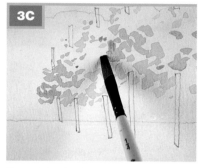

Suggest the vine leaves with the flat brush, sap green, cadmium yellow and cadmium red.

STAGE 3 The picture has begun to take shape.

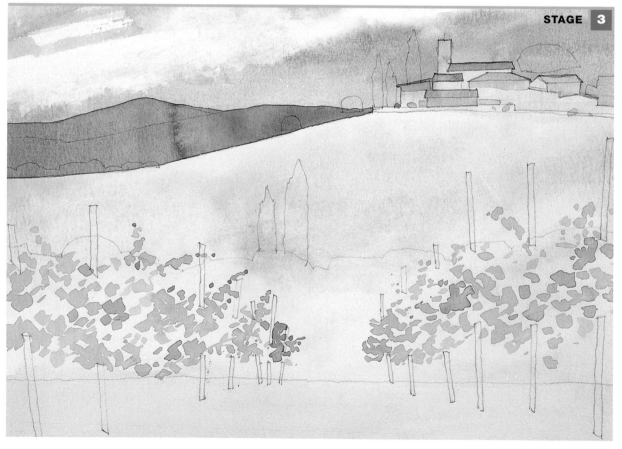

STAGE 3

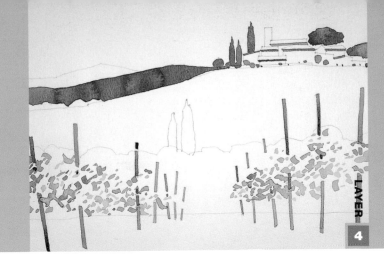

4 ADDING DETAIL

Darken the nearer distant hills with a mix of dioxazine purple and sap green. Paint shadows under the eaves with a mix of dioxazine purple and Payne's grey. Describe the trees and shrubs around the village with mixes of sap green, Payne's grey, raw umber and dioxazine purple. Add darker greens to the vines.

Take a dark wash of dioxazine purple and sap green over the nearer hills.

4A

4B

Add shadow detail to the buildings with a mix of Payne's grey and dioxazine purple, using the rigger.

Paint in the stakes with Payne's grey, again using the rigger.

4C

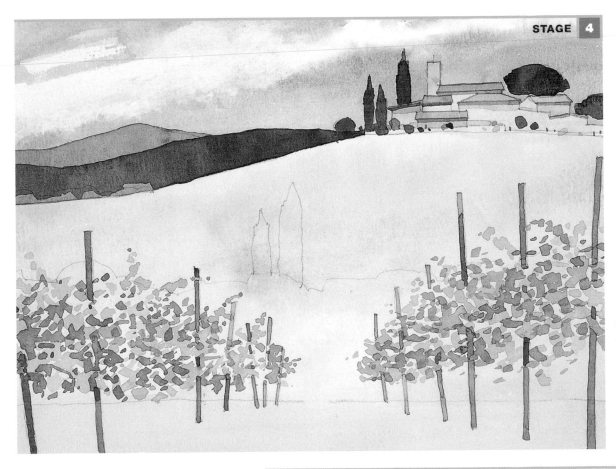

STAGE 4

STAGE 4

The distant hills and the village are almost complete. Diminishing perspective has been indicated in the brushstrokes for the leaves.

5 INJECTING DRAMA

Consolidate the detail on the buildings with the pencil. Use the candle to draw in lines between the vines on the hill that slopes down from the village. Wash a deep mix of Payne's grey and sap green over the slope. The wax marks will resist the paint and add texture to the rows of vines. Work the wash around the vine leaves in the foreground to make them catch the light.

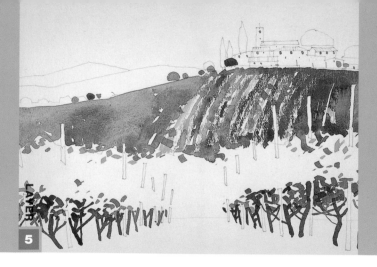

LAYER

5

Draw in the roof tiles with the pencil.

5A

Using the flat brush, paint a rich wash of sap green mixed with Payne's grey over the wax lines.

5B

5C

Paint the underside of the vines and their stems with a strong mix of raw umber and Payne's grey.

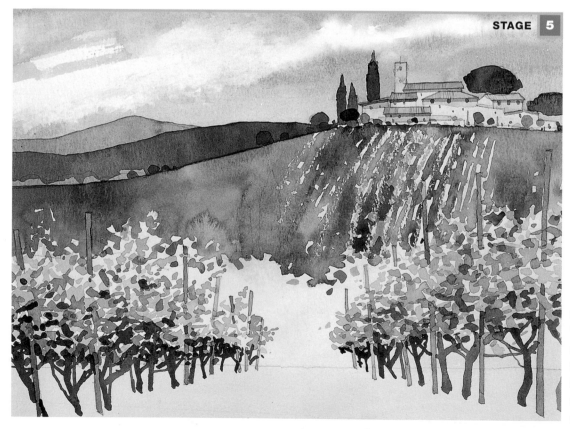

STAGE 5

STAGE 5
The middle distance and foreground have been strengthened, and the vine bushes are more rounded.

6 COMPLETING THE PICTURE

Add more detail throughout the painting. Use a dark green mix for the two trees near the centre; work this colour in and around the two rows of vines. Paint the shadows under the vines with a mix of Payne's grey and cadmium orange.

Paint in more trees and shrubs around the buildings.

Use a dense green mix to paint in the two foreground trees.

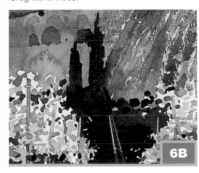

Paint the shadows under the vine bushes with Payne's grey mixed with cadmium orange.

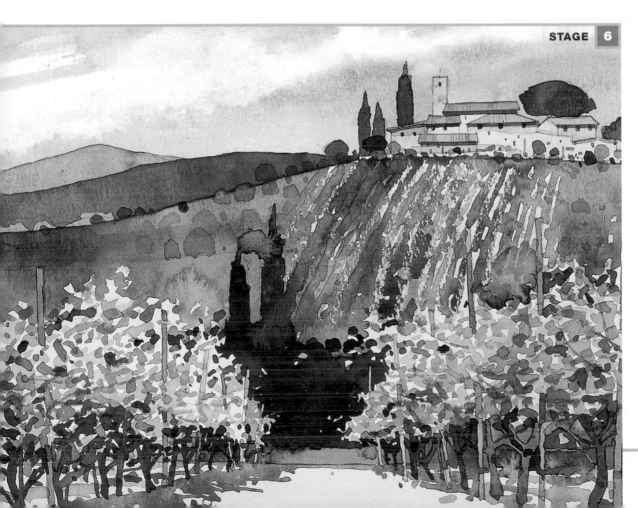

STAGE 6

STAGE 6

The strong contrasts in the foreground help the rest of the picture to recede. The difference in size and tone between the two groups of tall trees helps to create a sense of distance. Aerial perspective has been achieved through the use of cool colours in the hills and sky, and warmer colours – red, orange and raw umber – in the foreground.

INDEX

Author acknowledgements

I would like to thank all the artists who have contributed to this book: Glynis Barnes-Mellish, Ian Sidaway, Paul Talbot-Greaves, John Paige, Naomi Tydeman and David Webb. Special thanks also to John Paige for all his encouragement and advice, Robert Meadows for his expertise and endless patience in photographing many of the demonstrations, and all the team at Quarto, especially Liz Pasfield who was always at the end of the telephone line when needed.

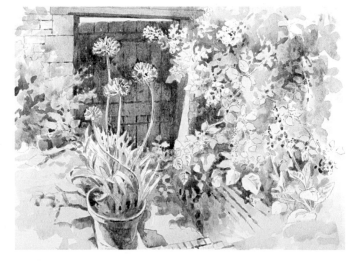

About the artists

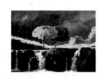

JANE LEYCESTER PAIGE
Pages 54–59, 60–65, 90–95 and 108–113

Jane is an artist with a deep experience of watercolour. She is a keen traveller and combines her love of painting and nature in her sketchbooks.

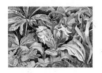

PAUL TALBOT-GREAVES
Pages 66–71 and 84–89

Paul's paintings are increasingly sought after by private collectors. His practical art book *Watercolour for Starters* is published by David & Charles.

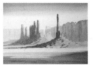

NAOMI TYDEMAN
Pages 72–77

Naomi runs her own successful gallery and artist's studio in Tenby, Wales, where she produces delicate and realistic watercolour paintings.

DAVID WEBB
Pages 78–83

David is a self-taught artist who runs popular workshops and painting holidays. He contributes regularly to art magazines and is the author of a book on still life.

GLYNIS BARNES-MELLISH
Pages 96–101 and 102–107

Glynis has been a major contributor to many books on watercolour and has lectured and demonstrated extensively throughout the UK and the rest of Europe.

JOHN PAIGE
Pages 114–119

John works in many different media on many different subjects, but his passion is for wildlife and portraiture.

IAN SIDAWAY
Pages 120–125

Ian is a professional artist who works across a wide range of media. He is the author of several practical art books and holds watercolour and drawing workshops in Italy.